M

PAINTING
Shapes
AND
Edges

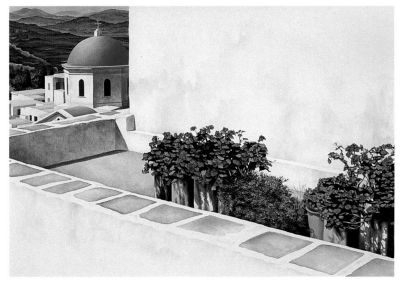

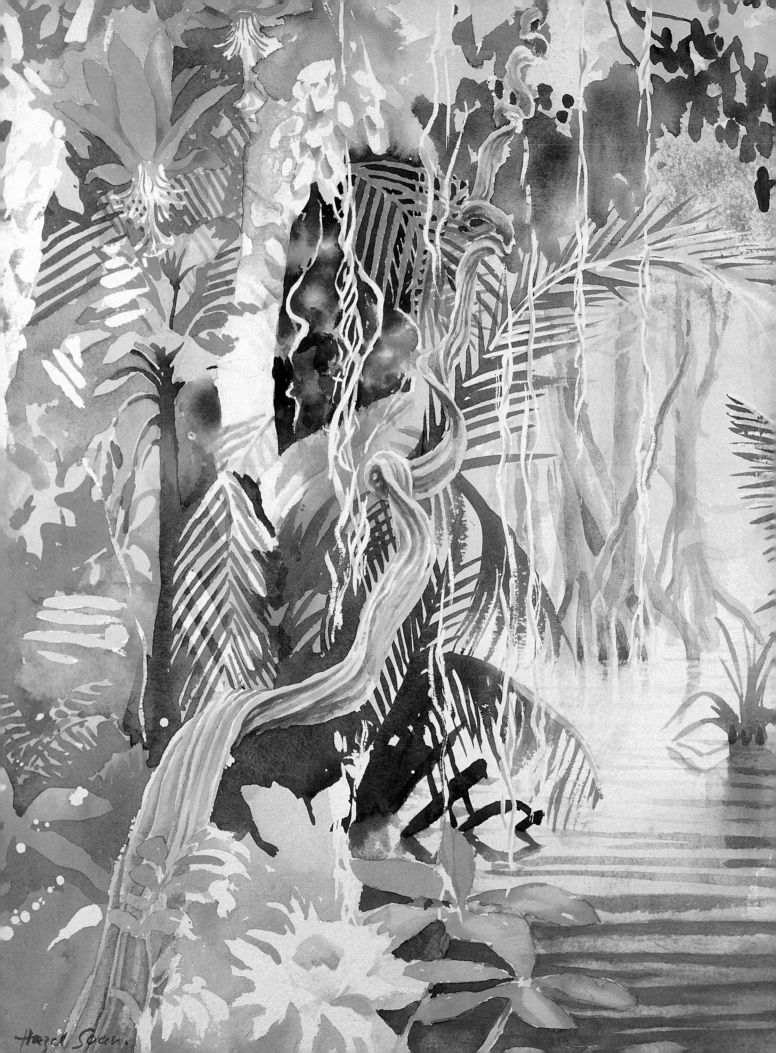

Hazel Soan.

Hazel Harrison

PAINTING
Shapes
AND
Edges

GIVE DEPTH,
CLARITY AND FORM
TO YOUR ARTWORK

**NORTH
LIGHT
BOOKS**

Cincinnati, Ohio

A QUARTO BOOK

First published in North America
in 1996 by North Light Books,
an imprint of F&W Publications, Inc.,
1507 Dana Avenue, Cincinnati, OH 45207
1-800/289-0963

ISBN 0-89134-735-6

This book was designed and produced by
Quarto Publishing plc
The Old Brewery
6 Blundell Street
London N7 9BH

Senior Editor Kate Kirby
Senior Art Editor Penny Cobb
Designer Caroline Hill
Photographers Colin Bowling, Paul Forrester,
Laura Wickenden
Picture Researcher Miriam Hyman
Picture Manager Giulia Hetherington
Editorial Director Mark Dartford
Art Director Moira Clinch

Typeset by Central Southern Typesetters,
Eastbourne
Manufactured by Regent Publishing Services Ltd,
Hong Kong
Printed by Leefung-Asco Printers Ltd, China

Foreword

THE TITLE "SHAPES AND EDGES" might seem to imply an abstract approach to painting, but in fact the book's primary aim is to build up your drawing and painting skills so that you are better able to present an accurate pictorial account of the world you see. The first and most important skill to acquire is that of analytical observation; whether you are painting a still life, a landscape or a figure study, you must be able to assess each shape and perceive the differences between one and another, both in kind and in scale. A series of exercises in the first part of the book will help you toward this artistic self-discipline.

The way we recognize a shape is by its outline, but this is a drawing convention rather than a reflection of reality – actual objects do not have hard lines around them. An outline only describes the outer boundaries of a shape, so after practicing outline drawing, you will move on to internal edges, contours, and ways of building up the forms through shading, tonal modeling and use of color.

The second section begins with useful tips for accurate drawing, and thereafter focuses on painting methods, with step-by-step sequences and finished paintings showing all the painting media in action. Here you will find practical advice on how to achieve soft highlights in watercolor, or crisp edges in oils, acrylics or pastel.

But although accurate evaluation of shapes and mastery of your chosen medium are both important, they are only foundation skills, so the final section of the book looks at the wider concerns of painting. As an artist, you are creating the illusion of three dimensions on a flat surface, so you must consider how to create a true feeling of space. You must also give thought to composition and color – how to place the shapes, and how to balance shapes, colors and tones in such a way that all the separate elements work together to form a harmonious whole.

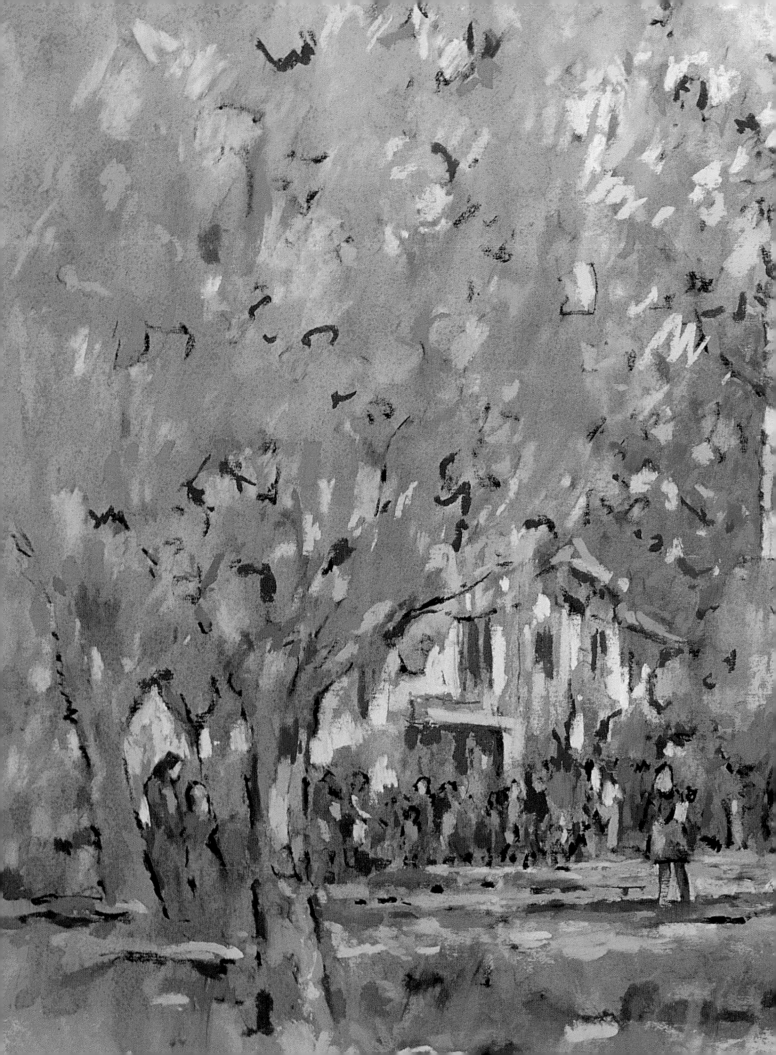

Contents

Part 1: Looking at Shapes and Edges

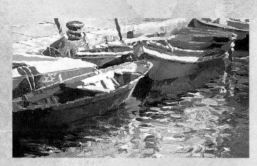

Part 2: Drawing and Painting Methods

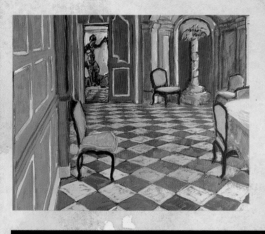

Part 3: Picturemaking

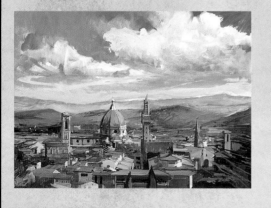

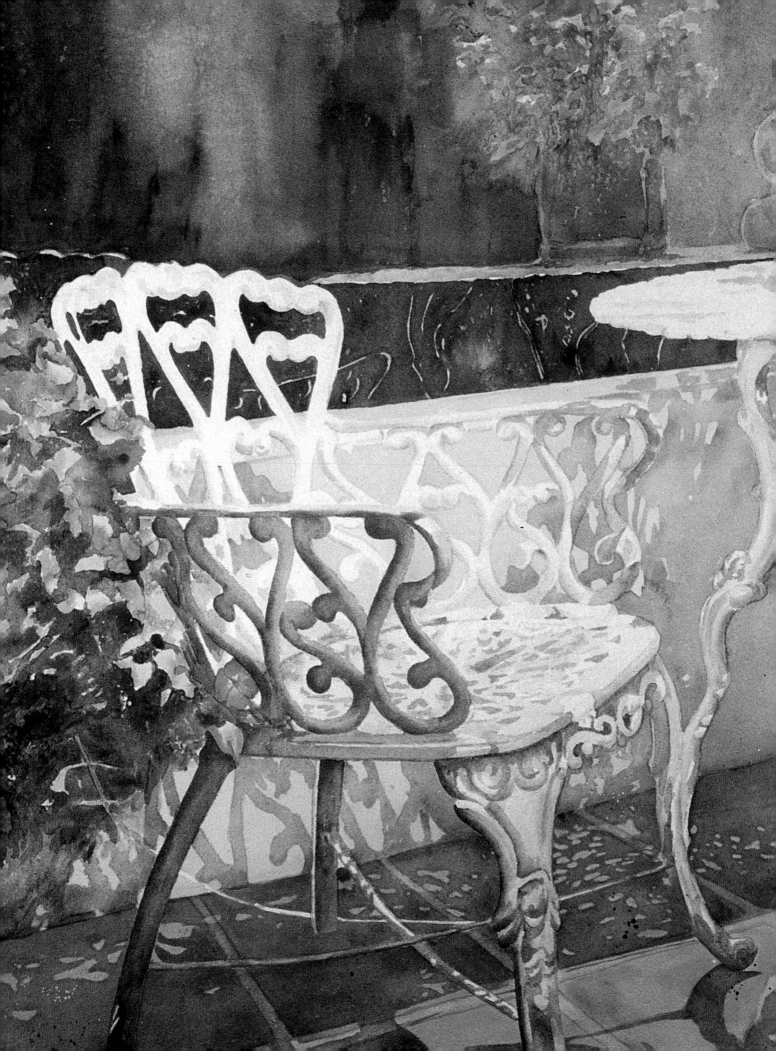

Part One

LOOKING AT SHAPES AND EDGES

THE FIRST THING YOU as an artist must learn to do is to represent shapes accurately, and this section of the book provides a series of exercises designed to help improve your drawing and observational skills. You will start with outline drawing, then learn how to vary the edges to achieve realistic effects, and how to make objects look solid by means of tonal modeling. The text begins by defining the different kinds of edges you will see in your subjects, and goes on to deal with the concepts of form, tone, and color.

Outlines

AN OUTLINE IGNORES EVERYTHING EXCEPT THE OUTER SHAPE OF AN OBJECT, BUT IT IS IMPORTANT BECAUSE IT IS THE MEANS BY WHICH WE IDENTIFY A SHAPE AND BEGIN TO DRAW OR PAINT IT

THE OUTLINE OF AN object tells us whether a shape is round, oval, geometric or irregular, and if several objects are grouped together, it also provides information about relative sizes and proportions. If you can make an accurate outline drawing – which can be surprisingly difficult – you are at least halfway to a convincing representation of your chosen subject.

The main problem in making outline drawings stems from the fact that so much other visual information gets in the way. If you are drawing an apple, the first thing you may notice is its color, and the second its roundness and solidity. When you draw the outline, you must ignore these interesting aspects and concentrate on the main shape, producing a two-dimensional "diagram," and this calls for self-discipline.

Preconceived ideas We all have a store of visual knowledge, which we unconsciously call on. We have an interior picture of a typical apple, vase, tree or face, for example, and this can be an impediment to good drawing. If you draw something you have never seen before, you will be forced to look really hard for the shape, but with something familiar you may find yourself "filling in" from your memory bank. The first skill for the artist to acquire is that of analysis, and that involves clearing your mind of preconceptions.

Visual ambiguity Because an outline is two-dimensional, it provides limited information. Some objects are immediately recognizable by their outlines, but others are not. A cup or vase with handles, or the profile of a face, fall into the first category; the viewer will be able to call on stored visual knowledge to guess at the internal shapes. The outline of a ball, however, will look exactly the same as that of a flat circular object, such as a plate hanging on a wall. If you place your hand on the table and draw around it, the result could not be

△ **Mother and Child** Geoff Marsters • pastel
The face and arm are in silhouette, but because of the accuracy of the outline, there is no ambiguity.

In Focus

It is easy to identify this object from the outline alone

An outline drawing of a face in profile can convey a lot of information

But an outline of a head tells us nothing about the person's face

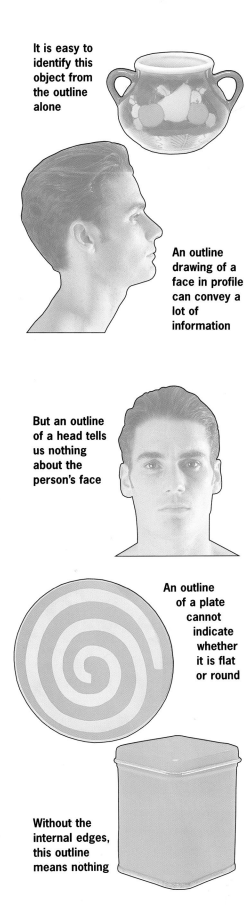

An outline of a plate cannot indicate whether it is flat or round

Without the internal edges, this outline means nothing

Drawing a silhouette *For this exercise, choose a single object with an interesting shape, such as a teapot or a pitcher with handles. The aim is to produce a silhouette using nothing but outline. Place the object against a plain light background, or on a windowsill, so that you can see its shape clearly, and avoid lighting that gives distracting highlights and shadows. You will not find it easy, but stay away from your erasers; if a line is wrong, simply draw over it. An incorrect mark provides a useful guide, whereas if you erase, you may repeat the same mistake. Draw the outer lines only, ignoring any shared edges, and as you work, try to analyze the main characteristics of the shape as though you were committing it to memory.*

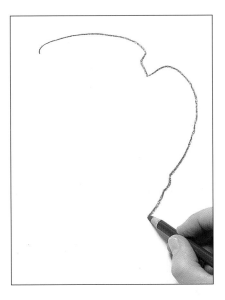

1 *The artist has begun at the top, with the outer edge of the ellipse, and now draws a continuous line around the handle and left side of the pitcher.*

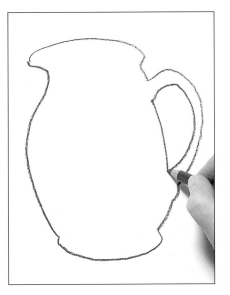

2 *Having taken the line around the other side, she returned to the inner edge of the handle, and now finishes by completing the left side.*

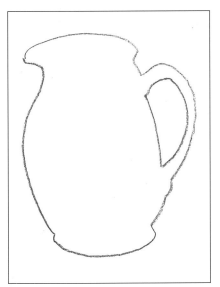

3 *The final drawing shows how difficult it is to draw an outline without erasing. Although convincingly shaped, the pitcher is tilted.*

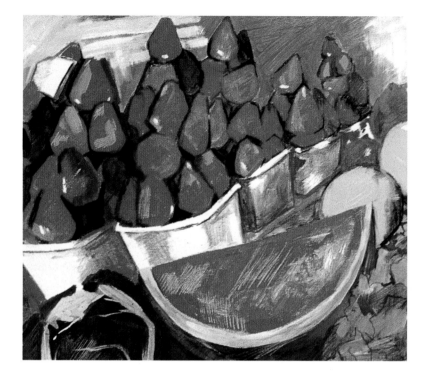

△ **Strawberries**

Helena Greene • acrylic

Hard outlines tend to destroy the impression of three-dimensional form, but here the artist's main interest was the flat-pattern aspect of the subject, with its varied shapes and vivid colors.

mistaken for anything other than a hand, but no one would know whether it is palm up or palm down. So, outlines, although important, are only the first step in making a drawing or painting.

Shared edges An outline drawing of two or more objects overlapping is usually less ambiguous because you can include the edges where the objects meet. These are called shared edges, and they provide additional visual information because they describe not only the shapes, but also the position of the objects in space – if one thing partially conceals another, it must be in front of it.

Another kind of shared edge occurs where two planes meet. For example, a box seen from an angle will have three shared edges, two where the top meets the sides and one where the sides meet each other.

Outline and edges *Now you are going to make a drawing in two stages. Put a group of three objects – such as a mug, bowl and plate – on a table, overlapping them so that there is no space between. Draw the outline made by the whole group, looking for the shape formed by all the objects together. Then, on the same drawing, put in all the shared edges you can see. This time you can erase if necessary, because you will probably find that once you begin on the shared edges, at least some of the outer lines will be incorrect. When you draw a shared edge, look carefully at the shape behind to check the size of the overlap, and look also at the bottoms of the objects, since their position establishes where they are placed in space, that is, on the tabletop.*

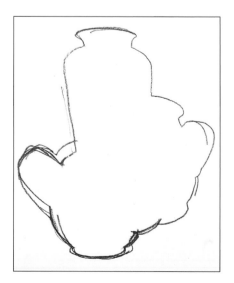

1 *An outline drawing is made first, ignoring the inner edges. Incorrect lines on the right have been drawn over rather than erased.*

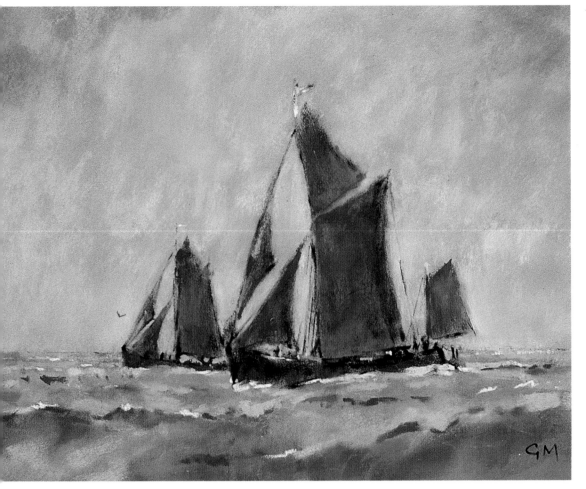

◁ **Barges off the Suffolk Coast**

Geoff Marsters • pastel

This painting demonstrates the importance of accurate outline drawing and careful observation of proportions. Any mistakes in the sizes and shapes of the boats' sails and hulls would destroy their credibility. To give a sense of movement, the artist has varied the edges, making them crisp in places and blurred in others.

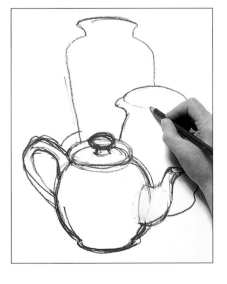

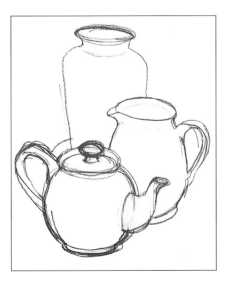

2 *With the handle, lid and spout of the teapot defined, the artist carefully draws the ellipse which describes the object's rounded form.*

3 *With the outlines and shared edges of all the objects drawn in, there is no visual ambiguity, and both the shapes and the forms can be clearly understood.*

Positive and Negative Shapes

THE SPACES BETWEEN OR BEHIND OBJECTS – THE BACKGROUND IN A STILL LIFE, OR THE PATCHES OF SKY BETWEEN TREE BRANCHES IN A LANDSCAPE – ARE KNOWN AS NEGATIVE SHAPES

In Focus

The vase and handles are well defined by the negative shapes

Identifying the negative shapes is helpful in figure drawing

NEGATIVE SHAPES, ALSO sometimes called "negative space," play an important role in drawing and painting for two reasons. The first is purely practical; looking at the spaces between things, and seeing them as definite shapes of their own, helps you to draw the positive shapes of the objects themselves more accurately. The second reason is concerned with picture making – the design of the drawing or painting. The picture will be more satisfying if the negative shapes provide a balance to the positive ones, rather than just being "left-behind" areas which are not seen as significant. This is especially important in still life; a painting can be let down badly by ugly, cramped-looking spaces where objects don't quite meet and may also be spoiled by too much space.

Comparing shapes You took the first step in assessing one shape against another when you drew the shared edges earlier. You were observing not only the outlines of the front object, but also how they affected the shapes

Drawing in negative *This is an extension of the exercise on page 11, where you drew the silhouette of an object by making an outline drawing. You will again be making a silhouette, but this time of a different kind, because you will not be drawing the objects themselves but the spaces between them. You will need at least three different objects including at least one with a handle, such as a pitcher or gravy boat, set out on a table against a plain background. Arrange the objects carefully so that the spaces between them are not equal. When you are happy with the arrangement, begin to fill in the negative shapes in black, checking each shape as you go, until you have a complete white-on-black silhouette. The best medium to use is black acrylic paint, applied with a brush (you can use white paint to make corrections); but if you don't have these paints, charcoal would be an alternative.*

❶ *Having arranged three objects – a pitcher, a statuette and a small straight-sided bottle, the artist makes a rough brush drawing and begins to fill in the negative shapes.*

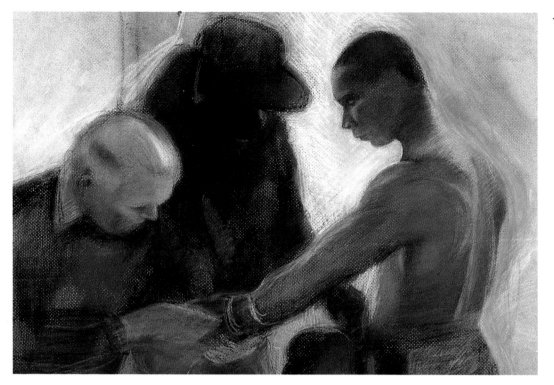

◁ **Tying Gloves**

Jane Stanton • pastel

This painting of three boxers illustrates the importance of negative space very clearly. The absence of any strong color allows the composition to be read in terms of the interplay of light and dark shapes, with the near-white negative shapes counter-pointing and strengthening the positive ones.

behind by cutting into them. Looking at negative space is much the same, but it requires a little more discipline, because it is natural to focus more on the actual three-dimensional objects you are drawing than on the flat wall or whatever is behind them. But it is well worth doing, and you really will find it helpful, particularly with any complex subject such as a still-life group with a lot of objects, or a figure drawing. It is useful even for single objects composed of more than one shape. Suppose you are drawing a pitcher with a handle and have difficulty under-standing the shape of the handle, and at what points it joins the body. You will find it much easier if you begin by drawing the negative shape between the handle and the side of the pitcher and then let the outer edge follow this.

2 *He now takes the black acrylic paint carefully down the edge of the statuette. Notice how well the small negative shapes formed by the pitcher's handle and the figure's raised arms describe the objects.*

3 *Black paint has spilled over the white shapes in places, so thick white acrylic is used to clean up some of the edges.*

Contours

T HE WORD CONTOUR MEANS THE SHAPE OR SURFACE OF A FORM, AND CONTOUR LINES ARE THOSE THAT FOLLOW THE FORM AROUND – A SERIES OF INTERNAL EDGES

AN OUTLINE IS ONE kind of contour, but it is similar to those on a map, which delineate the outer boundaries of a mass of land. Internal contour lines do much more than this, because they introduce the third dimension – that of depth. When an outline is ambiguous, the inclusion of contour lines can make a drawing quite specific. As mentioned earlier, a round object, such as a ball, and a circular one, such as a plate, both have exactly the

▷ **By the Sea**

Denise Burns • oil

A wealth of contour lines can be seen in this delightful painting. The stripes of the little girl's dress curve around her arm and over her back, where they flatten out to describe the plane and then change direction again over her thigh. The folds of the woman's dress, except where it is blown by the wind, are equally descriptive of form, as are the edges of the shadows on the sand.

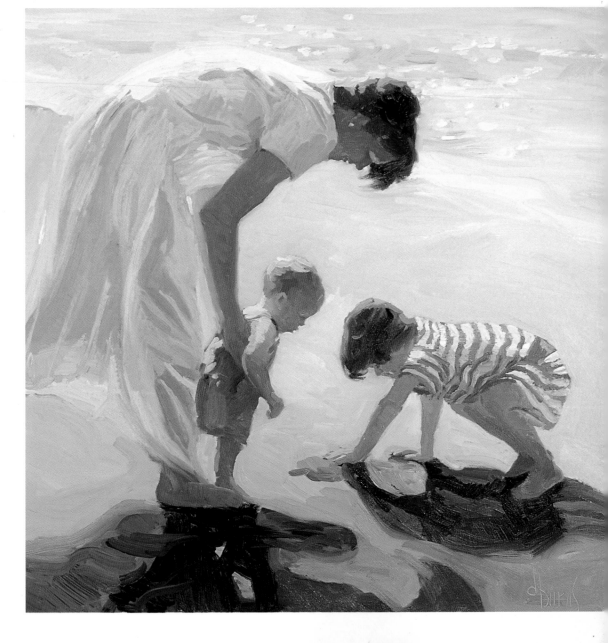

In Focus

Stripes follow the forms of the body, sloping upward at shoulders

Clear curving contour lines running up from base and converging at top

Small indentations provide visual clues about shape and form

Strap is straight on flat plane of wrist, curving sharply round edges

Drawing by feel *Art teachers often ask their students to draw without looking at the paper. This is partly to counter a common tendency to pay more attention to the drawing than the object, but the other purpose is to make you feel as though you are in direct touch with the subject. Choose any item that is not regular and symmetrical, but which has good contour lines and an interesting outline. An old walking shoe, or a chair would be suitable – or you can draw your own hand or even a figure. Draw in line only, keeping it as continuous as possible, and looking at your paper only when you need to reposition your drawing implement. Don't restrict yourself to outline; let your hand follow inward to the internal contour lines.*

1 *Using a black conté pencil, which gives a strong line, the artist feels out the outlines and contours. She does not look at her drawing, and repositions the pencil only when necessary.*

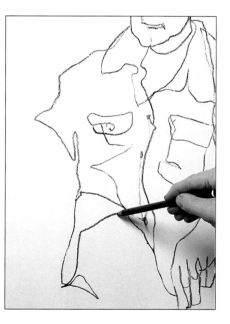

2 *Moving downward, she lets the pencil follow the folds of the sitter's shirt. This contour line is important because it curves around the top of the thigh.*

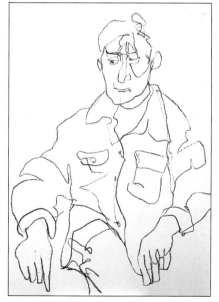

3 *The drawing, which took no more than ten minutes, expresses the forms and posture remarkably well, and the proportions are surprisingly accurate.*

Drawing three dimensions *How you carry out this exercise depends upon how ambitious you are. The aim is to build up the impression of a solid shape through the internal contour lines provided by a regular pattern. You could pose someone (or draw yourself in the mirror) wearing a striped garment, or portray an arrangement of patterned objects such as vases and dishes. Use color if you find it more interesting, but don't apply heavy shading to suggest the forms – this will come later. Draw all the edges you can see, beginning with light outlines to establish the shapes, then progressing to shared edges and contour lines. If you are drawing cups, don't forget the ellipses, and try to make these as symmetrical as possible (more about ellipses on page 44).*

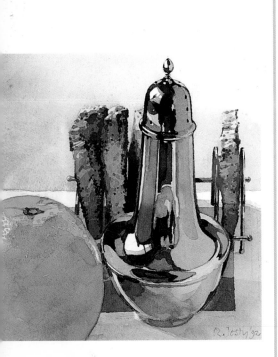

△ **Sugar Caster and Grapefruit**

Ronald Jesty • watercolor

The shape of the sugar caster is precisely defined first by the ellipses, which provide contours circling the form, and second by the shape of the reflections on the cylindrical top part. Reflections on metallic surfaces often need simplification, as they can confuse the form. The artist has looked for the main shapes, dividing them into separate crisp-edged areas of light, dark and middle tones. Subtler contours appear on the grapefruit and toast, where the tiny highlights and shadows created by the textures follow the forms.

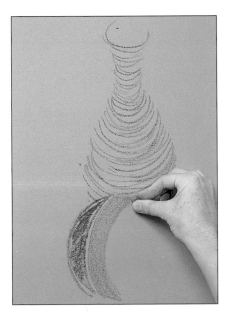

1 *Working in pastel on colored paper, the artist concentrates on the contour lines. The concentric rings on the bottle have been drawn in lightly with the tip of the pastel, and here she uses the side for broader strokes.*

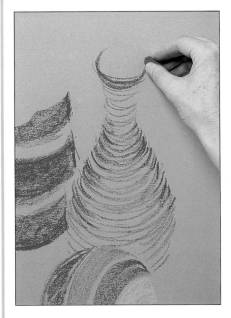

2 *She takes special care with the ellipse, which is wider than the rings beneath because of the trumpet shape of the neck. She is viewing the objects from slightly above, so the ellipses are well defined.*

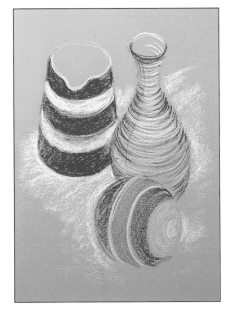

3 *Although there is little tonal variation except for some slightly darker lines at the sides of the glass vessel, the forms are adequately explained through the contours.*

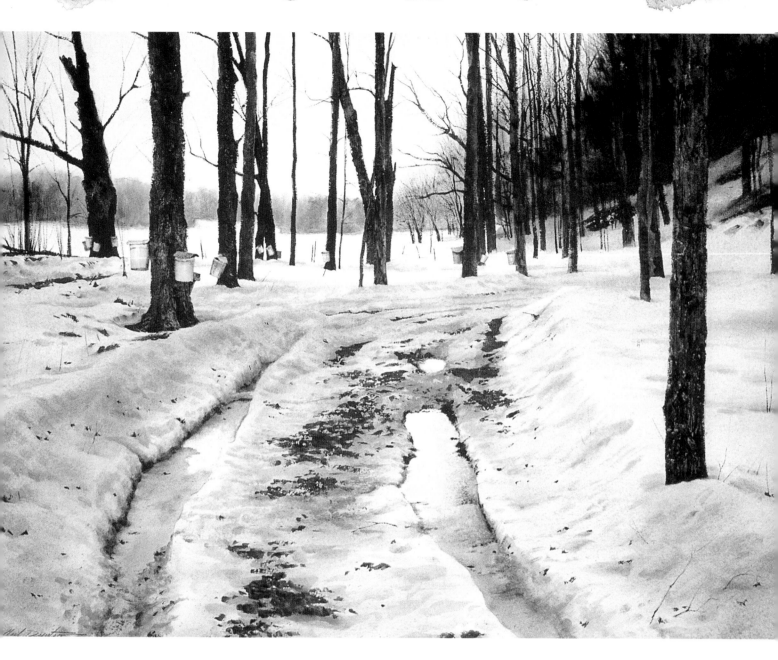

same outline, but if the ball has stripes or a band of lettering running around it, and you include this, you will have begun to portray its volume as well as its circularity.

You can't see contour lines on all objects, and sometimes they are subtle, but often they are obvious. Like the hypothetical design on the ball, regular-patterned fabric provides a series of easily read contour lines – the stripes of a T-shirt will curve around an arm. The edge of the ellipse at the top of a mug is a contour running around the shape – this is also a shared edge where two planes meet.

With practice, you will learn to recognize a shape by its outline and make an accurate two-dimensional drawing, but giving the

impression of its form is more difficult. The main way of doing this is through shading, which will be discussed later, but in the early stages of drawing shapes, it helps to imagine contour lines even if you can't see them. Look hard at an organic object with an irregular shape, such as a potato, a pear or a pepper, and try to "feel out" the surface by thinking about the way contour lines would behave if they were there.

△ **Chittenden Sunset**

Neil Drevitson • watercolor

The uneven surface of the snow has produced a series of small shadowed indentations which act as contour lines to explain the dips, swells and flatter planes of the ground.

Soft and Hard Edges

THE EDGE QUALITIES OF OBJECTS VARY WIDELY. THESE DIFFERENCES ARE CAUSED BY THE SHAPES OF THE OBJECTS, THEIR COLOR IN RELATION TO THEIR SURROUNDINGS, AND THE EFFECTS OF LIGHT

In Focus

White background gives crisp outlines; internal edges are softer

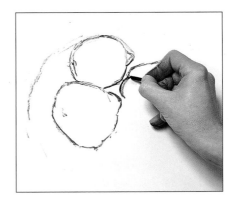

Light from above and in front picks out nearest edge of rim

Side lighting gives clear edge on shadowed side; right side is soft

YOU HAVE NOW DISCOVERED that you can make a fairly realistic drawing of shape and form using only lines, but you can give an even better impression of form by varying the weight of those lines.

Lost and found edges Look at any object and you will see that some of the edges appear clear while others may be hard to discern. This is a result of the way in which light strikes the object. Experiment by placing a flowerpot on a windowsill so that it is lit from behind. The lower edge of the rim will be visible at the edges, but will almost disappear in the middle.

Edges or parts of edges that can't be seen, although you know they are there, are known as "lost" edges, while the sharp ones are referred to as "found." If you observe them carefully, you can create a more expressive outline, varying the strength of the line you use in a way that suggests form and light as well as shape.

Sometimes one side of the outline of a rounded object, such as a vase or pot, seems

Varying the line *For this exercise you need a group of objects of different shapes, some rounded and others flat. A good selection might be a vase with handles; a plate with two or three pieces of fruit on it; and a knife and fork. You will be exploring the way in which the shapes of the objects affect the edges, so you want a drawing medium that can give a variety of lines. Charcoal, conté pencil or black pastel pencil would all be suitable, and with any of these you can soften lines to lose an edge simply by rubbing with a finger. Set up the group on a table in a good light. Start the drawing with a light outline to place the objects, and then build up the drawing with thick and thin, light and heavy lines. Look for any lost edges; you may be able to describe an entire shape simply by "finding" one small part of the edge.*

1 *The shapes are established with line alone, using a stick of medium willow charcoal. Charcoal lines can be strengthened, or made lighter by smudging, as the drawing progresses.*

▷ **Charlotte** Maureen Jordan • pastel
The figure gives a strong sense of form and solidity. Outline has been avoided, but after laying on the colors, the artist "found" a few key edges with delicate touches of charcoal or white pastel.

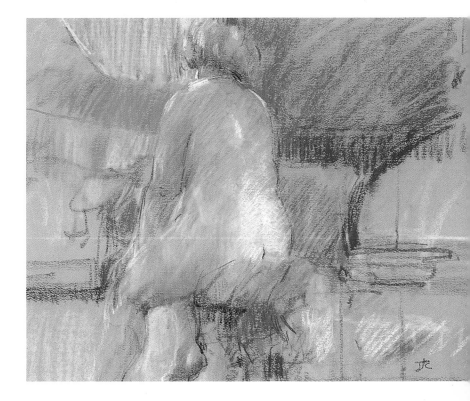

to dissolve into its surroundings, either because of a strong shadow or highlight, or because it is similar in tone or color to the background. In this case you need to soften or lose the line on that side, perhaps "finding" it in one or two places with small, light marks, and using a more emphatic line where the edge is distinct. The drawing will still make sense, because the viewer will focus on the well-defined side and assume that the other side of the object is the same. A good rule in drawing and painting is to avoid putting in anything you can't see clearly.

Different edges for different shapes The effects of light are only one thing to look for; the shape of the object also dictates the quality of the edge. The surface of any rounded form is turning into or away from the light, and what you perceive as the outline is actually the point where it curves farthest away from you. Drawing this as a hard line of even weight is a misrepresentation; it will make the object look like a cutout, reducing three dimensions to two.

Where you will often see sharp, clear edges is on flat-surfaced or cube-shaped objects, such as books, tables or boxes, and here you can use decisive lines. But there will still be variations; the back edge of a table may be in shadow, or similar in tone to the background, and therefore much softer than the front edge, or even partially lost. Another factor in the quality of edges is the surface texture, which we will look at later on.

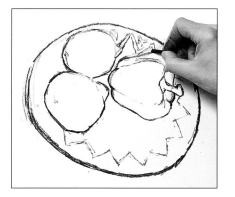

2 *The artist has begun to vary the line, using heavier pressure and a thicker line in some places.*

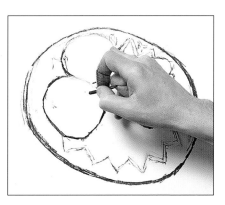

3 *The two pieces of fruit are similar in tone, so the shared edge is "lost." This and the top of the lemon has been smudged with a finger.*

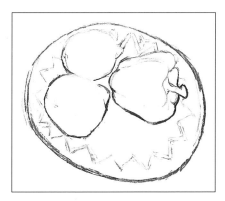

4 *After a further slight smudging of the internal contour lines on the bell pepper, the lines at the bottom edges, where the forms turn away from the light, were given more weight.*

The Components of Shapes

Nᴏᴛ ᴀʟʟ ᴏꜰ ᴛʜᴇ ᴏʙᴊᴇᴄᴛꜱ ᴡᴇ ᴅʀᴀᴡ ᴀʀᴇ ᴏɴᴇ ꜱɪᴍᴘʟᴇ ꜱʜᴀᴘᴇ. ᴏꜰᴛᴇɴ ᴛʜᴇʏ ᴀʀᴇ ᴄᴏᴍᴘᴏꜱᴇᴅ ᴏꜰ ᴍᴀɴʏ ꜱᴍᴀʟʟᴇʀ ᴏɴᴇꜱ, ᴀɴᴅ ᴡᴇ ʜᴀᴠᴇ ᴛᴏ ᴜɴᴅᴇʀꜱᴛᴀɴᴅ ʜᴏᴡ ᴛʜᴇʏ ꜰɪᴛ ᴛᴏɢᴇᴛʜᴇʀ

Tʜᴇ ᴏʟᴅ ꜱᴀʏɪɴɢ ᴀʙᴏᴜᴛ "not seeing the woods for the trees" expresses just what can happen when there are other shapes within a main one. You concentrate on the components and lose sight of the overall outline, or find you can't fit the smaller shapes into it. It is relatively easy to manage when two-dimensional shapes are imposed onto a three-dimensional surface, such as in a printed pattern. The design on a dish won't interfere with your perception of the shape, so you would begin with an outline and add the pattern. But sometimes the components are themselves three-dimensional, and this can be considerably trickier.

Obvious examples of multi-part shapes are a cauliflower, composed of several flowerets, a summer tree with its clusters of foliage, and a bunch of grapes. Less obvious would be a clump of trees, or flowers in a vase. In both these cases, particularly the second, it is hard to concentrate on the outline of the whole because the eye naturally registers the smaller shapes. But you should always look for the main shape first, just as you did on page 12 when you drew the outline of a group of objects before putting in

Simplifying the shapes *Floral groups are a potential pitfall. Because flowers are so eye-catching, as well as being complex shapes in themselves, it is natural to begin with them, but it is not wise. If you draw each flower separately, you will often find that they don't fit properly, or sit convincingly in the vase. For this exercise you will need a massed group of daisy-like blooms, either cut flowers or a houseplant such as a chrysanthemum. Outline the entire main shape lightly with charcoal, treating it as a silhouette. When you are sure the shape is correct, work into the drawing, defining the vase and the chief flowerheads, but trying to see them as simple shapes – circles or ellipses.*

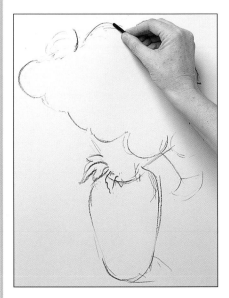

❶ *The main shapes are identified, and the artist checks the proportions of flowers to vase before making a light outline drawing with willow charcoal.*

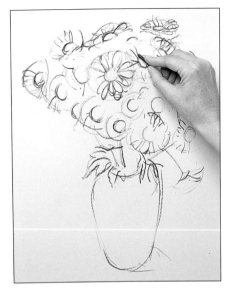

2 *She now begins to build up the separate shapes of the flower heads, relating each one to the overall outline and paying attention to the angles at which they are set.*

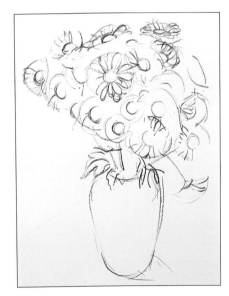

3 *A drawing like this, while not botanically precise, would be fine as an underdrawing for a painting. Any further detail required would be built up gradually in color.*

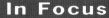

In Focus

Because of the darker background, the overall shape of the pale trees can be read clearly

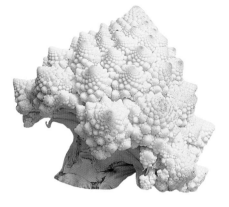

The florets become smaller at the top, but retain the same shape throughout

Each flowerhead can be seen as a basic circle, changing shape according to the angle of viewing

◁ **Street with Cypress Tree**

Nick Harris • watercolor

Two-dimensional pattern and texture presents less of a problem than irregular three-dimensional shapes, but there are pitfalls. It is easy, for example, to make the stones or bricks of a wall too large or small, which may result in a bizarre and illogical structure. Here they have been depicted in detail and with complete accuracy.

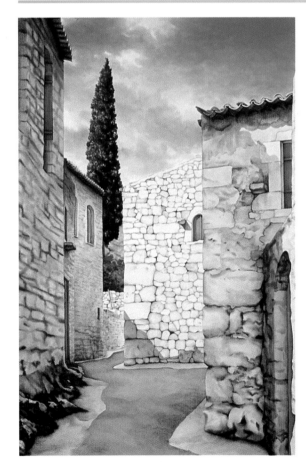

the shared edges that defined each one. If you have trouble identifying the larger shapes, look at the subject with your eyes half-closed. This cuts out much of the distracting detail and lets you perceive the main masses as dark against light or vice versa.

Diversity of shapes But sometimes there is no clear outline that defines a shape; instead, what you see is a collection of different shapes seemingly – or actually – stuck together. Some man-made objects come into this category: chairs, for example, can include many shapes, from a circle or square (the seat) to tapering cylinders (the legs), to curves (arms or backrest). Here you would have to begin with the outline or one or two "key" shapes, such as the seat or back, and fit the arms and legs into them in a logical way.

▷ **Sketchbook Study**

John Lidzey • watercolor and pencil

When painting trees, this artist always begins with the main shape of the canopy, blocking it in lightly with watercolor washes and then building up detail either with more watercolor or with a drawing medium.

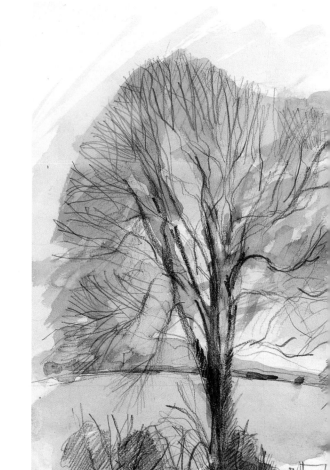

Comparing shapes *Most painting subjects, whether landscape, figure or still life, contain a number of different shapes of varying sizes, which you must learn to assess against one another. Drawing a single object composed of different shapes helps you to acquire these analytical skills. A chair, preferably one with a circular seat, is an ideal subject, since you will have to identify each shape as well as seeing how they fit together. Use any drawing medium you like, and begin with an outline of the largest component. Keep the lines light so that you can erase or draw over them if they are wrong – or use charcoal, which can be erased simply by rubbing. Once you have established the main shape, look carefully at the way the others relate to it, assessing the proportions by asking yourself questions such as, "Are the legs longer, shorter or wider than the backrest?"*

❶ *The largest shape, that of the seat, was drawn first, and the shape, angle and relative size of the backrest is assessed against this.*

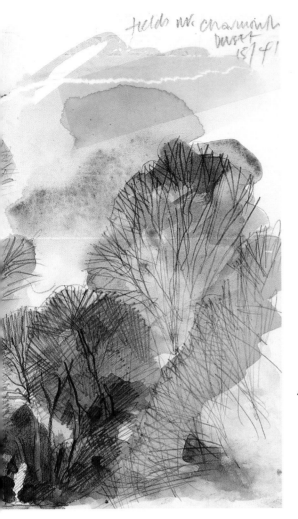

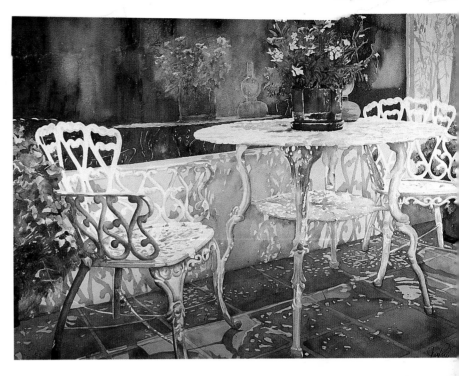

△ **A Sunny Garden** Joan I. Roche • watercolor

The delicate ironwork of the furniture and its corresponding shadows have given the artist an opportunity to create a lively and unusual outdoor still life. Complex shapes like these are not easy to draw, but you can usually see how each of the components fits into a main shape, and if you begin by outlining it, making sure the proportions are correct, you will be able to build up the smaller shapes gradually.

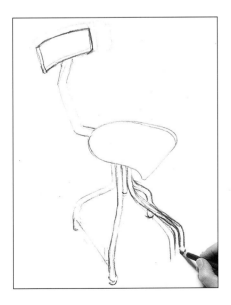

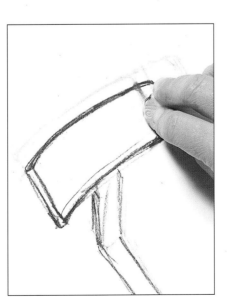

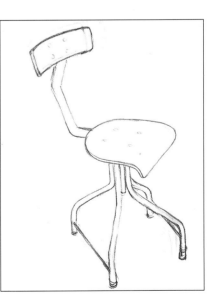

❷ *The legs and the bars joining them are complex and hard to draw, and have necessitated some reworking.*

❸ *As the drawing progressed, one shape was checked against another. The backrest was too large, so some lines are erased and redrawn.*

❹ *As important final touches, the lines showing the exact thickness of the seat and backrest, and the small studs on the seat, were added.*

Shape and Form

DRAWING OUTLINES AND CONTOURS IS AN IMPORTANT FIRST STEP TOWARD ACCURATE REPRESENTATION, BUT OUR PRIMARY MEANS OF MAKING OBJECTS APPEAR SOLID IS TONAL MODELING

A BLIND PERSON CAN tell the form of an object by running his or her hands over it, and can identify the hardness or softness of any edges. The fall of light does much the same for sighted people; like an unseen hand, light plays on and around an object, creating areas of light and dark that model the form and "feel out" the different edges.

Light and dark As we have seen, you can suggest form in a drawing by varying the line to differentiate between hard and soft edges. But when you start to paint, you won't be using line, except perhaps to make a preliminary outline drawing. Instead you will be giving the impression of form by tonal modeling – the painterly equivalent of shading.

This involves being able to recognize the tones of the colors you see – the word tone simply means the lightness or darkness of any color regardless of its hue. Seeing in terms of tone can be difficult and needs practice, since color is always the first quality that we register. If you are asked to describe a lemon, for example, you will say it is yellow. You won't say, "Well, most of it is light yellow, but the highlights look almost white and the shadows are fairly dark greenish-brown." But the latter description is much more accurate

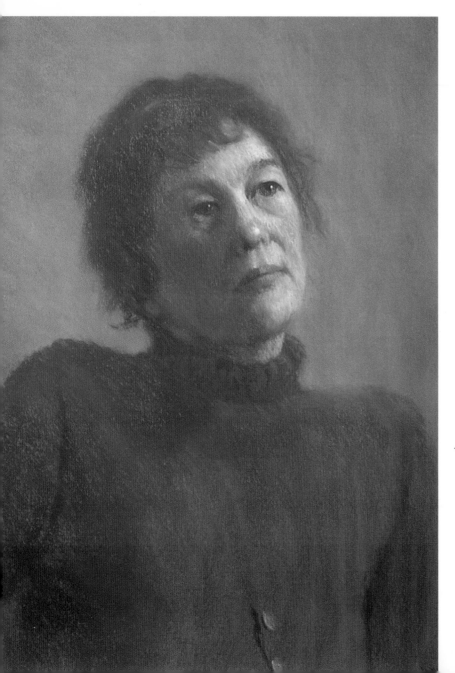

◁ **Mary**

Richard C. Pionk • pastel

The light comes from slightly in front and to one side of the sitter, a form of lighting often used by portrait painters because it shows up the forms well. The modeling of the face is primarily tonal, but the shadowed side is not simply a darker version of the skin color. The artist has introduced lovely subtle red-browns and dark pinks where the face reflects color from the sweater.

Drawing in tone *Because it is difficult to think about tone when you are also worrying about how to analyze and mix colors, it is a good idea to practice tonal modeling in monochrome first. Set up a still-life group with a variety of shapes, including an item with a reflective surface and one or two organic objects, such as fruit or vegetables. Make sure that the group is in a good light so that you can see the forms clearly; light coming from one side and slightly above is best. Using conté crayon, soft pencil or pastel, build up the drawing by shading, trying to avoid outline altogether if you can, or using it just to establish the shapes.*

In Focus

The tonal variations can be seen most clearly in the black and white photograph

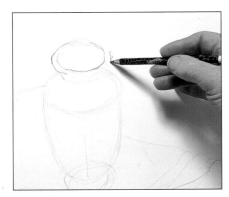

1 *A light drawing is made to establish the shapes and proportions of the objects. This is a wise precaution, as it is more difficult to correct a heavily shaded drawing than an outline.*

2 *The artist is using a very soft pencil, so she is working from the top down to avoid smudging completed areas and messing up the paper.*

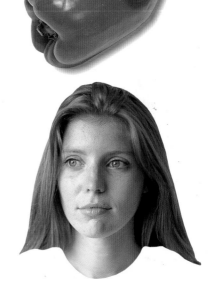

Tone changes are gradual on cheeks and forehead, and more abrupt on nose and chin

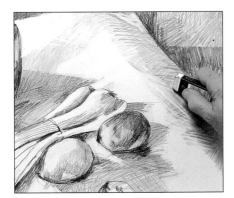

3 *An eraser is used to soften the shading at the edge of the tablecloth. Erasers are an essential tool for tonal drawings in charcoal or pencil, as they can be used to pick out highlights or lighten areas that have become too dark.*

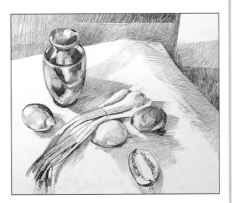

4 *Soft pencil can be rubbed with a finger to create gentle gradations, but this artist prefers a linear approach, using hatching and crosshatching to impart energy to the drawing.*

Tones blend into one another on body of pot, rim produces clear highlight

Sharp divisions between tones mark the interlocking planes

from a painting point of view, and that is how an artist will think of the object – in terms of both color and tone.

Shadows and highlights The next thing to observe is whether there are sharp divisions between lights and darks, and if so what kind of shape each area of tone makes. This tonal pattern is like a surface map. A cube-shaped object has sharply defined planes, and the tone of each will be relatively even, with a hard-edged boundary between each one, but on a rounded shape there will be a subtle gradation from light to dark.

A shiny surface is a bonus, because it will have highlights whose shape helps to explain the main form. On complex forms, such as human faces or limbs, both shadows and highlights make definite shapes according to the various planes and surfaces.

▷ **Pumpkins and Dried Leaves**

Irene Christiana Butler

• pastel

There are no hard-edged boundaries between the light and dark tones on the pumpkin, and the highlights are softer than they would be on a shiny surface. The brittle surface of the leaves and cast shadows creates much clearer edges, marked by sharp transitions of tone.

△ **Catherine Backlit**

Daniel Stedman • acrylic

Lighting is particularly important in figure and portrait painting, because the colors are subtle and the forms complex and often hard to read. This bright light coming from above creates clear, sharp-edged highlight shapes on the thighs, softer ones on the breasts, and some lovely shadow colors on the lower legs.

Drawing with cut paper *If you have tried the previous exercise, you may have found it hard to identify the most important tones, and perhaps ended up with a meaningless mass of middle tones. This exercise helps you to be more selective, because you are limited to five tones. The subject should be a face, lit from the side so that there is a good pattern of shadow and highlight; you could use a photograph from a magazine. You will need four grays, from dark to light, which you can make by scribbling with pencils of different grades on thin paper. Your white drawing paper provides a highlight tone. Start with an outline drawing as a guide, then look for the darkest tones, cutting pieces of paper to fit the shapes and gluing them on with paste.*

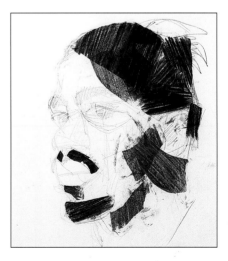

❶ *The tones of the face were first explored in a pencil drawing, and the artist then began to glue on pieces of preshaded tracing paper. Because the paper is semi-transparent, very dark tones can be built up by layering.*

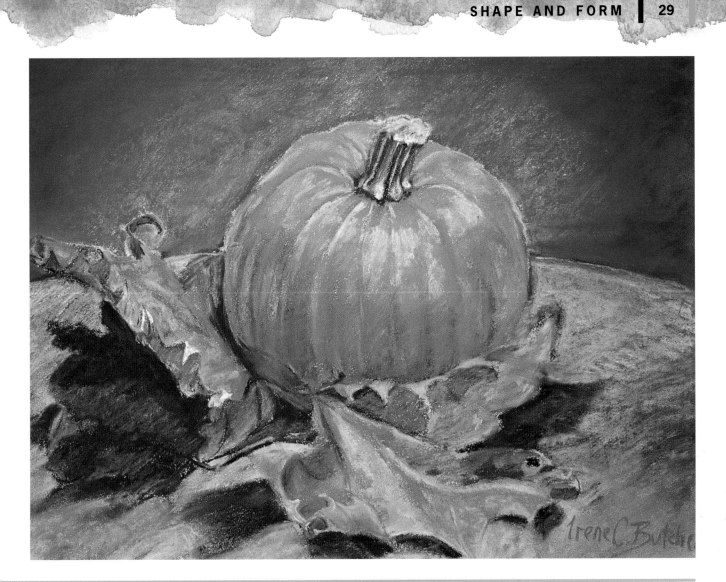

2 *Thin tracing paper is used, as it is easy to tear to the required shape, and it was colored using several different grades of pencil and one charcoal pencil heavily applied for the near-black tone.*

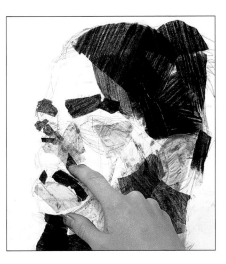

3 *In a painting you would progress from large brushstrokes to smaller ones, and the artist uses the same method here, adding smaller pieces to define the features and facial hair.*

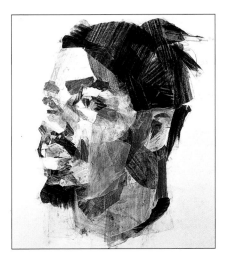

4 *In the final stages, the shadow over the cheekbone was seen as over-dark, so a layer of clear tracing paper was used on top. The finished collage is a lively and remarkably accurate study of form.*

Form and Color

SHAPES ARE RECOGNIZED BY THEIR COLOR AS WELL AS THEIR OUTLINES. THE STRONGER THE CONTRASTS OF COLOR BETWEEN AN OBJECT AND ITS SURROUNDINGS, THE EASIER IT IS TO SEE THE SHAPE

ALTHOUGH YOU MAY SEE a shape's outline clearly, you must also consider its volume, and this involves assessing the variations of color within each object. As we have seen, the play of light creates areas of light and shade which model form, but the light also affects the colors themselves, sometimes surprising you.

Local color When you look at anything – a tree, a piece of fruit, a flower, a garment – you will automatically give it a color name, describing it to yourself as green, yellow, red, pink, or whatever. This actual color is known as local color, and it is important to be able to recognize it and decide what kind of green,

▷ **Daisies and Peaches**

Richard C. Pionk • pastel

This painting illustrates very well how local color is modified by the fall of light. The main pastel colors used for the fruit are yellows, deep reds and greenish-browns, yet they still read as orange. On the vase, the local color is seen only on the bands of rich blue running down the form. Most noticeable of all is the effect of light and shade on the white cloth; no pure white can be seen at all.

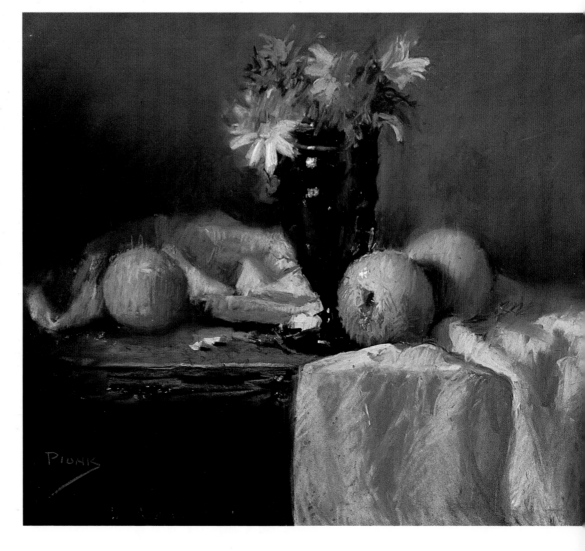

Painting local color *One of the first painting skills to acquire is that of accurately identifying the colors you see, and learning to mix your paints to match the reality. Painting a still-life setup using nothing but local color is an instructive exercise; you will need to analyze each color as well as thinking about the different shapes and how they relate to each other. You will need a good variety of shapes and colors for the group, but avoid anything with a very obvious local color, such as lemons and oranges – these are too easy, and the colors come straight from the tube.*

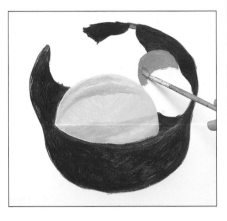

❶ *The artist is using acrylic, which can be applied flatly with little variation of color and tone. The blue bowl was painted first, as this strong color provided a key against which to judge the subtler local colors of the fruit.*

The highlights on the forehead are bluish, departing from the local color of the skin

The tone and color variations are less marked on this pale skin

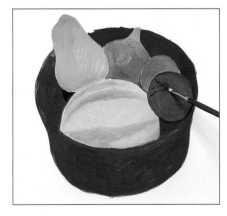

❷ *When assessing local color, you must consider not only what kind of color it is, but also its relative lightness or darkness. This red is almost the same tone as the bowl, whereas the other fruits are very much lighter.*

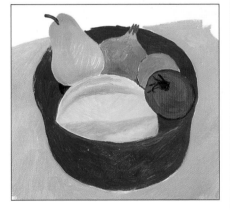

❸ *Using only local color gives little or no impression of form, but as you can see from this picture, it allows you to exploit the flat-pattern element of painting as well as helping you to learn to identify and mix colors.*

Greens of trees become paler and bluer as they recede; tonal contrast progressively diminishes

yellow, red or pink it is, and whether it is lighter or darker than surrounding colors.

But when you begin to explore the effects of light on an object, you may find that you can't see much of the local color. If you are painting a portrait of a person in a red sweater, the hue in its pure form may only be visible in areas where the light strikes most strongly. Shadows caused by folds and wrinkles and the forms of the body beneath will probably not be red at all, but brownish or purplish depending both on the light and on what kind of red the garment is.

So tonal modeling is not just a matter of making the same color lighter or darker; you will nearly always have to introduce other colors. These must, however, be consistent with the local color, or you will lose the redness or yellowness altogether and end up with a mishmash of unrelated colors.

Color and space Local color is also affected by the position of an object in space. You will see this most clearly in landscape subjects because the space is greater than in, say, a still life. A tree close to you will be a much more intense green than one in the middle distance. If both trees are of the same species, you will know that they have the same local color, but they won't look the same; the more distant tree will be paler and bluer.

Another difference between the two trees is that you will see much greater variations in color and tone in the nearby one. Distance reduces detail and softens contrasts, making the shape easier to "read." If you have trouble identifying a shape because the variations of color and tone are confusing, try the trick of half closing your eyes, which has much the same effect as pushing the object away from you in space.

▷ **Dissolving Palette**

Hazel Soan • oil on paper

Smooth-surfaced objects tend to pick up touches of color from their surroundings, and these reflected colors can alter the local colors in unexpected ways. You can see the effect particularly clearly on the red boat. In the middle, the mingled blue and reds of the water have bounced back to create a purple hue. The blue boat similarly has picked up some of the brilliant yellow of the water, resulting in cooler turquoise blues.

Form and color *Now try describing both the local color and the variations – painting what you actually see rather than what you know. You can paint the same group as before, but it might be better in this case to choose objects with obvious colors, since the aim is to discover how light affects them. Oranges and lemons, red and green peppers, or evenly colored ceramic items would all be suitable. The lighting is important; you will see more of the local color under a flat front light, so avoid this. Instead, light the group from one side (you can use artificial lighting) so that there is a strong pattern of light and dark.*

❶ *As in the previous exercise, the artist has begun with the largest area of color – in this case, the mid-blue tablecloth – so that she can relate the other tones and colors to it. The local color of the orange is quite close in tone to the blue.*

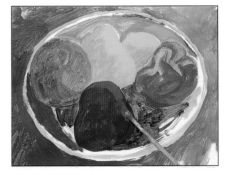

❷ *Having painted the red bell pepper as a flat color, she now begins to build up the forms by using a lighter, more orange red.*

3 *The orange has been lightened with yellow and white on one side and darkened with small flecks of reddish brown on the other, and highlights are now added to the pepper. These reflect some of the color from the tablecloth, so she uses white mixed with a little blue.*

4 *Both the local colors and the variations have been faithfully represented. Notice how the colors reflect each other, with touches of green in the yellow bell pepper and lemon, and a band of yellow on the green bell pepper.*

Cast Shadows

Cast shadows provide an exciting extra element in a drawing or painting. They also help to explain the shapes of the objects that cast them

Cast shadows are caused by an object blocking the light, and because they are directly related to the light source, their shape will change according to its direction. They are not like mirror images or reflections; there will always be some distortion of the form, which is part of their fascination.

If you have ever enjoyed the effects of low evening sunlight, and seen the long,

Using shadows creatively *In landscape painting, you can't tell the light what to do; you have to choose the time of day that gives the best shadows. But in still life you can control the lighting, so this is a good way of discovering how shadows behave and how to utilize them in your composition. Try three different lighting arrangements for the same setup, so that shadows are cast first on the background, then on the table in front of the objects, and finally at the sides. Choose any items, but include a piece of cloth so that you can see how the edges of the shadows are interrupted by the folds of the fabric. Paint each variation if you want to, or select the one you find most interesting. Work in color, because the colors of shadows are as vital as their shapes.*

❶ *In this arrangement the light comes from the left, behind the objects, casting shadows forward. Notice how the folds of the drapery break up the shadow shapes.*

In Focus

Edges of shadows are clearly identified on this smooth surface

Creamy beige surface imparts more color to shadows; rough texture softens the edges slightly

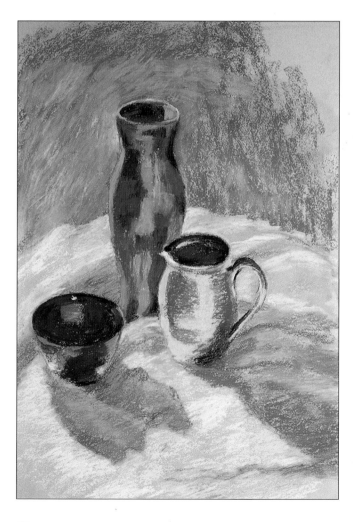

❸ *With the light behind the artist's left shoulder, a dramatic shadow is cast on the background to become a positive shape in its own right. All three of the paintings are in pastel.*

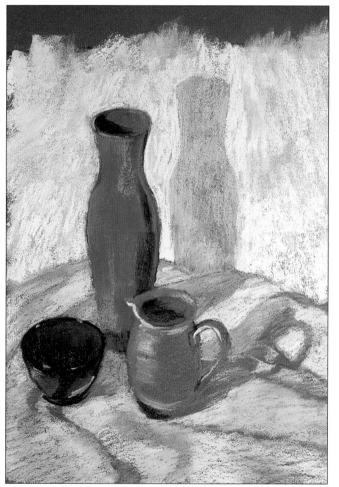

❷ *Here the light source is directly on the left and lower than before, throwing the shadows sideways. Again the line of the shadow is broken, undulating over the folds of the cloth.*

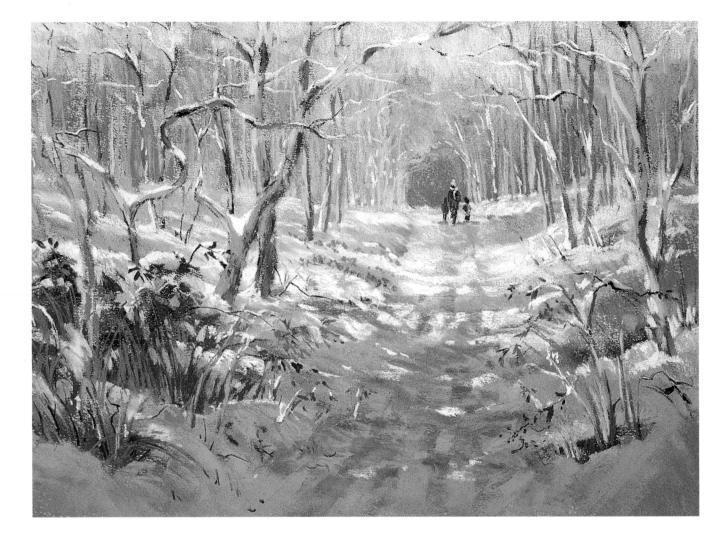

△ **Woodland Walk** Jackie Simmonds • pastel

The shadows play a descriptive role, providing contours that describe the lie of the land, but they are also essential to the composition. The interplay of shadows and bands of light creates a horizontal pattern that balances the uprights of the trees and background figures. Tonal contrasts are subdued, in accordance with the gentle winter light, but the artist has emphasized the shadow and light pattern through her use of muted versions of two complementary colors – mauve and yellow. These pairs of colors, opposite one another on the color wheel, "spark each other off" to create vibrant effects.

slanting shadows which create patterns on the ground and pick out details on hillsides or buildings, you will appreciate that shadows can be a major factor in a painting, or even its main focus. The bands of shadow thrown across a road by trees on either side, for example, will act as balance for the verticals of the trees, giving a strong geometric framework to the composition and creating interest in an area which might otherwise be dull.

Descriptive shadows Sometimes you can describe an object almost entirely by its shadow. For example, you could suggest a window in a sunlit room without including it in the picture, simply by painting the

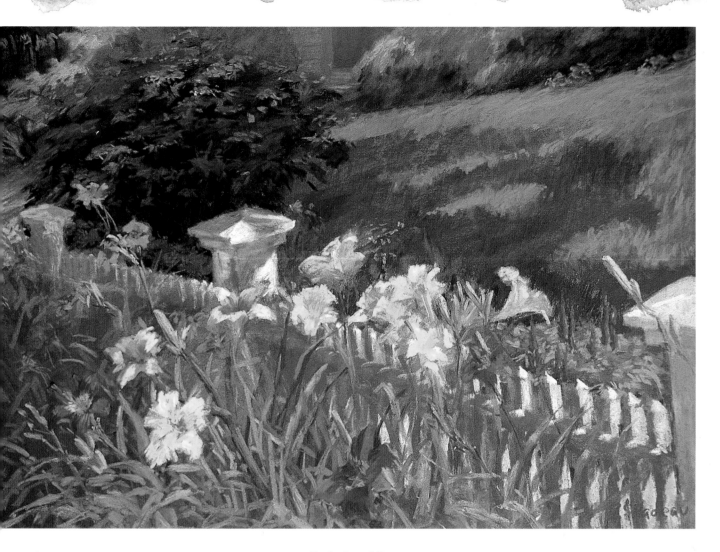

△ **Early Day Lily** Rosalie Nadeau • pastel

Without the strong cast shadows, the area of grass behind the flowers would have been dull and featureless. As it is, they break up the area into dark and light shapes and provide a tonal balance for the dark bush on the left and a shape balance for the diagonal line of the fence. The dark shadows, in which the artist has introduced deep mauve-blues, also set off the brilliant yellows of the flowers.

shadows cast on the floor by the bars. If you are painting part of a building, the shadow may complete the description by showing rooflines and chimneys which are out of your picture. Dappled shade in the foreground will indicate the presence of trees, even if they themselves are behind or to one side of you.

Shadows and surfaces Shadows also tell you a lot about the shape, form, and texture of the surface on which they are cast. On a perfectly smooth horizontal plane, the edges of shadows will be sharp, but if there is any surface irregularity, they will be softer and more broken. A shadow cast on a level, newly mown lawn will look very different from one cast on rough grass, where the edges will be broken by tufts or clumps. The ground beneath the grass may also be uneven, so the shadow will change shape, dipping and rising with the swells, hummocks and hollows. It may even disappear in places, becoming a series of small shapes. Think of shadows as contour lines following the forms of the land, and observe them carefully.

A problem, of course, is that when you are out painting landscape you are subject to a moving light source, and shadows will alter in shape and direction as well as color. If the shadows are central to your composition, block them in as early as possible and try not to change them too much as the day wears on or your picture may become confused.

Surface Texture

SURFACE QUALITY PROVIDES VITAL CLUES ABOUT AN OBJECT. BY PAYING ATTENTION TO FORM AND TEXTURE, YOU CAN MAKE A CONVINCING RENDERING WITHOUT USING COLOR

WE KNOW THAT LIGHT describes form by creating areas of light and dark, but the kind of tonal contrasts you see depend on an object's texture as well as its shape. A hard, shiny surface reflects more light than a matte one, causing clear highlights and well-defined areas of tone. Highlights on a matte surface may be almost imperceptible, represented by a slight lightening of the local color, and there will be no distinct edges between light, dark and middle tones.

Line and texture Texture also affects outlines, edges and contour lines. Drape a piece of heavy fabric over a table, and the hard line of the table front will become a soft one. The outline of a ball of fluffy wool yarn or a child's soft stuffed toy won't be hard and clear; it will be broken by the surface texture, becoming a series of tiny marks or dots rather than a continuous line.

In landscape you will seldom see hard outlines, edges or contour lines. As we noted

In Focus

Shiny surface produces sharp-edged highlights and strong tonal contrasts

On matte surfaces, highlights are soft and diffused; tonal contrasts slight

Outlines and internal edges soft and fuzzy, reflecting the texture

Silky fabric is reflective, giving strong tone and color contrasts

Fabrics *Drawing or painting fabrics is a good way of discovering the effects of surface texture on forms and edges. Silk or satin will naturally fall into sharp folds, almost like pleats, with fairly obvious edges, but woolen or other heavy fabrics will make larger and more rounded folds, and edges may only be marked by a difference in tone and color between two areas. You will need at least two different kinds of fabric or articles of clothing, one heavy and the other light. Arrange them with plenty of visible folds, and make a monochrome tone drawing, avoiding line as far as possible.*

1 *A wool sweater and a silk scarf have been draped over a chair, and the artist is drawing with conté crayons. He has begun with the background to provide a contrast for the light color of the scarf.*

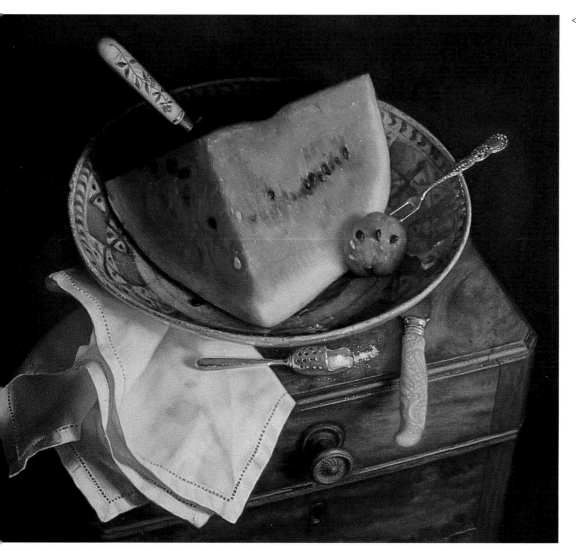

◁ **Watermelon in Blue Russian Dish**

Deborah Deichler • oil on panel

Minute attention to texture was one of the features of the Dutch school of still-life painting in the 17th and 18th centuries, and this artist shares their interest. Her technique, with no visible brushmarks, is also influenced more by past than present oil-painting methods. Working on an aluminum panel faced with fine linen, she has achieved an amazing degree of detail as well as exciting contrasts.

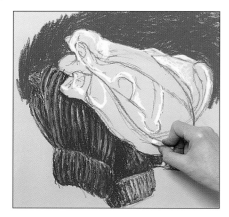

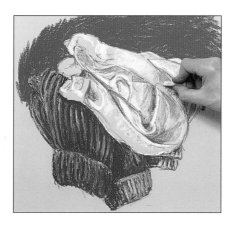

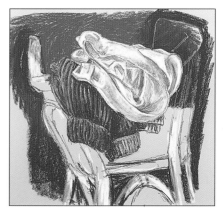

2 *Dark brown and white conté were used for the ribbed texture of the sweater, and white is now applied on the scarf. The paper is tinted, so the white shows up as a slightly lighter tone.*

3 *Although the scarf is light in color, its silky texture produces sharp folds resulting in strong tonal contrasts. Red-brown and white conté crayons are combined for this area.*

4 *The finished drawing shows the pronounced difference in texture between the two fabrics. In the final stages the chair was indicated to provide a context for the study.*

▽ **St. Michael's Mount**

Jeremy Galton • oil on board

The texture of the beach is economically suggested with individual brushmarks of light and dark paint, which become smaller toward the middleground, with less pronounced tonal contrasts.

on the previous pages, shadows will be fragmented by clumps of grass or other irregularities in the ground. The outline of a tree will comprise different edges, lost in places and found in others. Most of these edges won't be perceived in terms of line, but as areas of darker or lighter tone, varying in size and thickness.

Description and disguise Some textures are helpful in describing form, because they provide contours. The light and dark pattern made by the bark of a paper birch tree, for example, curves around the trunk, supplying strong clues to the form. A regular texture such as the slightly pitted surface of an orange

is seen as a series of dots, diminishing in size as the form curves away. Similarly, the pebbles of a beach appear ever smaller as the beach recedes, so you can describe this flat plane in a painting by decreasing the size of your brushstrokes or pastel marks.

Other textures can disguise forms. If your model is wearing a heavy coat or a thick knitted sweater, you will find it difficult or impossible to see the forms of the body and limbs. The garment will impose its own forms on those beneath. But a tight T-shirt or silk blouse will reveal the forms clearly, with folds and wrinkles creating contour lines.

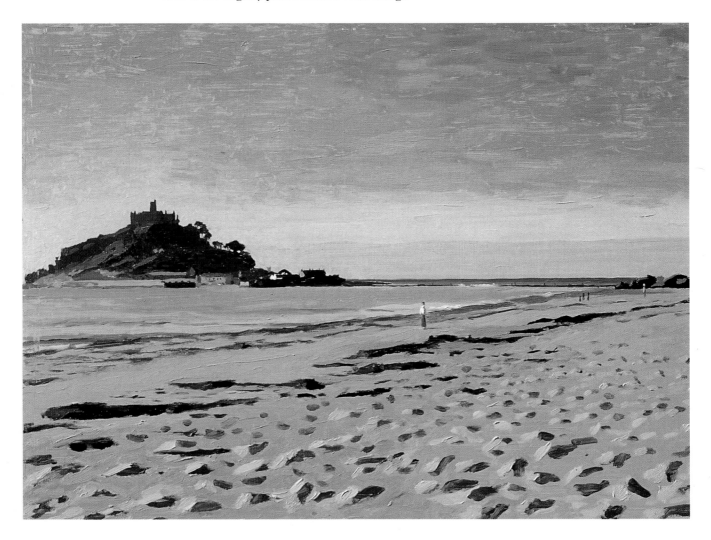

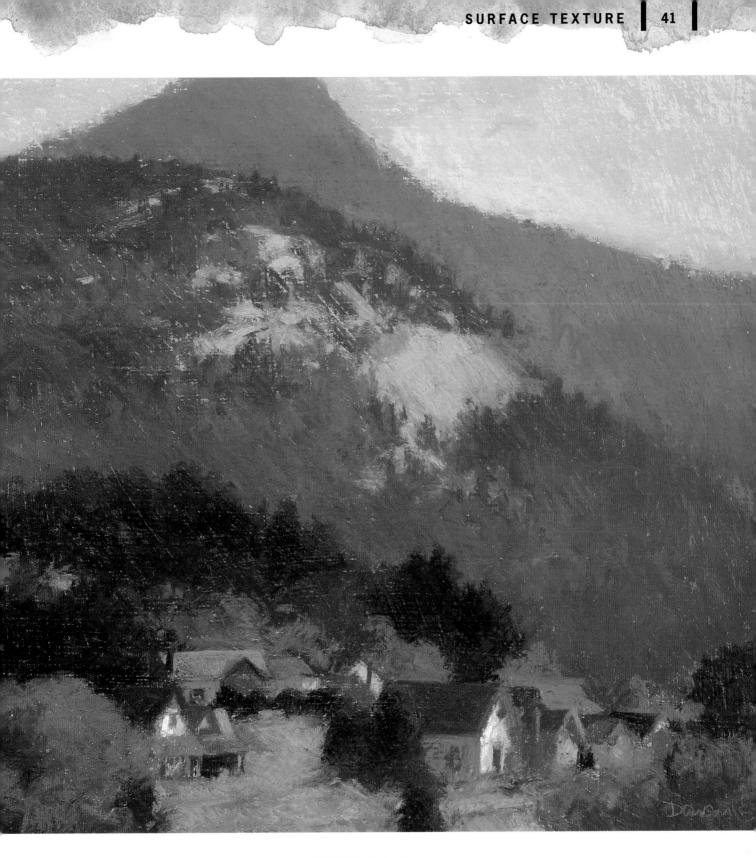

△ **Field Study in Pine** Doug Dawson • pastel
The texture of the most distant tree-clad hill is suggested entirely by the way the edges have been handled, with light, broken marks used where the trees meet the sky. On the middleground hill and in the dark trees behind the houses, there are touches of definition and color variations within the shapes, but again, most of the "story" is told through the broken edges.

Shape and Perspective

WHAT YOU SEE OFTEN APPEARS TO CONTRADICT WHAT YOU KNOW, BUT TO DRAW AND PAINT SUCCESSFULLY YOU MUST LEARN TO LOOK HARD AND TRUST YOUR EYES

WE HAVE SEEN HOW distance affects the color of objects, but this is only one of the changes that takes place. A distant object will also appear smaller than one in the foreground, even if both are the same size. This apparent shrinking of things as they recede from you (known as the law of diminishing size) is the basis of the whole system of linear perspective, which is our primary means of depicting spatial relationships.

▽ **Filofax** Sara Hayward • acrylic

The effects of perspective depend on your viewpoint. The artist is looking down on her still-life arrangement, so there is very little distortion, and she has made an intriguing and unusual composition based on the interplay of rectangles and diagonals. The muted color scheme and strong contrasts of tone suit the austerity of the subject.

Changing shapes You will find out more about using perspective to create space in Part Three, but here we are concerned with how it plays tricks with shapes. Hold a book up in front of you and you will see its "real" shape – a rectangle – and its real size. But

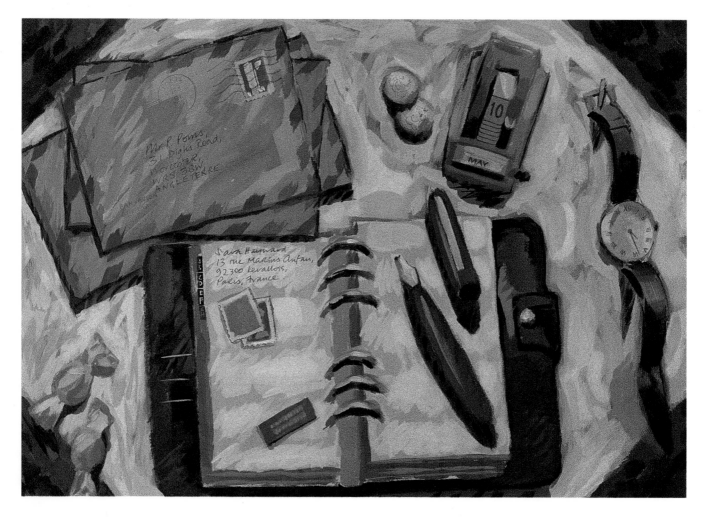

In Focus

These two books are exactly the same size and shape

The shape of the top of the stool when viewed from a standing position

A lower position, with the stool top nearer to eye level

At precisely eye level, the top is not visible

From above, the ellipse is very open, a near-circle

Nearer to eye level, it narrows into a shallow oval

Only the front curve of the ellipse can be seen from below eye level

Drawing rectangles *This exercise sounds dull but is actually fairly difficult, and will give you valuable practice in judging the effects of perspective and in assessing relative shapes and sizes. Arrange a pile of about six variously colored books on a table so that they are all corner on but at different angles. Position yourself so that you can view the table straight on, with the front forming a horizontal line. Make a drawing or painting, checking the angles of the various diagonal lines against the horizontal of the table front. If you are not sure of an angle, hold up a pencil and tilt it until it coincides with the line, then take the pencil carefully back to the paper and mark it in. This is a common method of checking angles.*

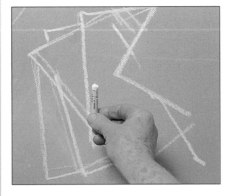

❶ *The artist begins with an outline drawing in white pastel. She checks lines by holding up a pastel stick against the subject and return it to the drawing, held at the same angle.*

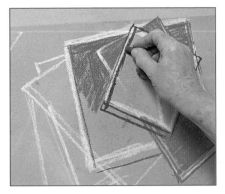

❷ *The pastel color is applied as flatly as possible, as uneven pressure would result in tonal variations, contradicting the flat planes of the books.*

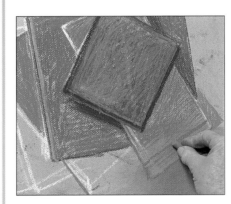

❸ *With the colors of most of the books filled in, she sees that the proportions are incorrect, so she rubs down the pastel and redraws the line at the bottom.*

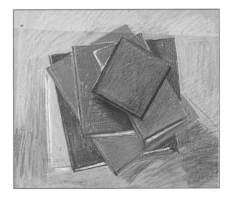

❹ *More colors have now been added, with a sharp band of white and then green overlaying the original error, which is no longer visible. The yellow background, added last, has the effect of sharpening the edges of the books.*

place it on a table and there will be an apparent change in both shape and size. The front edge will be the same width as before, but the book's height, or the length from front to back, will be shorter – an effect called fore-shortening. Also, because things appear smaller as they recede, the line at the back will be shorter than that at the front – the rectangle will have changed into an irregular straight-sided shape. You will see this even more clearly on a larger object such as the table itself.

The basics of perspective If you have good observational skills, you may be able to draw perspective effects accurately by eye, but understanding the rules is helpful, if only to enable you to check when things go wrong. It is all too easy to underestimate the effects of foreshortening and diminishing size simply because of what you know about the real shape and size of objects.

The system of linear perspective is based on the idea that all receding parallel lines meet at a certain point – known as a vanishing point – on an imaginary line called the horizon. Although you can't see this line, you always know where it is, because it is your own eye level. It is important to remember this, because the angle of the receding lines, and therefore the shapes, will alter according to where you are viewing from. Look at the book or table again, first standing up and then sitting down. The foreshortening effect will be greater when you are seated because your eye level is lower.

If you look at a solid object, such as a box, from an angle, there will be two vanishing points, with the tops and bottoms of both sides appearing to slope inward. Both vanishing points, however, will meet on the same horizon line, which remains constant at eye level. Do not move position when you are drawing, or your eye level will change.

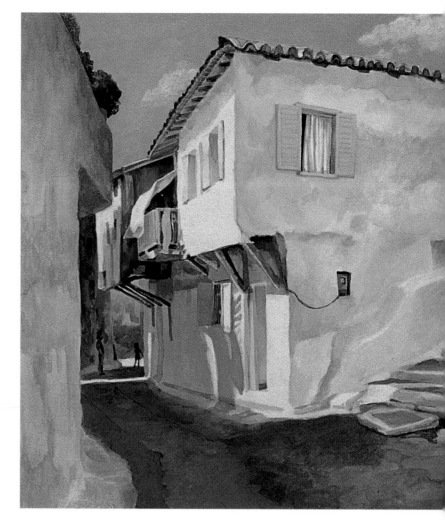

Ellipses Circles are also affected by perspective, flattening out and becoming ovals. These ellipses often cause confusion, but the principle of foreshortening is the same as for other objects. Just as the book became shorter when you looked at it sitting down, so will the top of a cylinder, or the opening of a mug or vase. From above you will see a near-circle, but the ellipse will become progressively shallow as your eye level lowers, until it ceases to be an ellipse and becomes a straight line. So when you are representing cups, bottles, vases and so on, remember that the ellipse at the top will be shallower than that at the bottom; in a tall bottle, there will be quite a pronounced difference between the two.

△ **House with Yellow Paint**

Jill Mirza • acrylic

The central house has two vanishing points, one for each wall, because it is at an angle. The roof is well above the artist's eye level, so she sees only the underside of the overhang, and the diagonal of this and the top of the left-hand house slope sharply downward.

Cylinders and circles *If you are interested in still-life subjects, you will need to practice drawing ellipses. Choose a few cylindrical objects, such as mugs or glasses along with one square or rectangular shape such as a place mat. At least one of the cylinders should be glass, because this allows you to see the ellipse at the bottom as well as the one at the top. Begin with a light outline drawing, then draw or paint, building up the forms by shading or tonal modeling. To ensure that both sides of the ellipses are equal, draw a faint central line as a guide.*

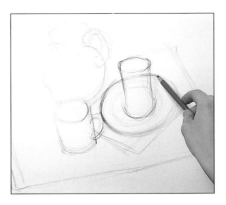

❶ *The objects have been arranged on a low table so the ellipses are wide and open, with the plate almost a circle. A light drawing is made in conté pencil.*

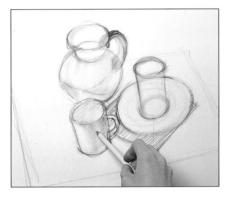

❷ *Before redefining the ellipses, which so far have only been sketched in, the forms are built up by lightly smudging white into the earlier brown and black.*

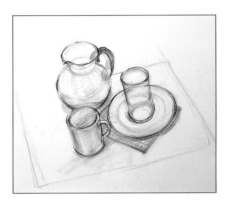

❸ *It is easier to draw ellipses when they can be seen in the context of the forms, so they were left loose until the final stages and then drawn in more strongly.*

▷ **Still Life with Frosted Blue Glass**

Jackie Simmonds • pastel

Ellipses can play an important role in the composition of a still life, so choose your viewpoint with care. The artist is looking down from a standing position, and the ellipses form open oval shapes which counterpoint the near-circles of the background flowers.

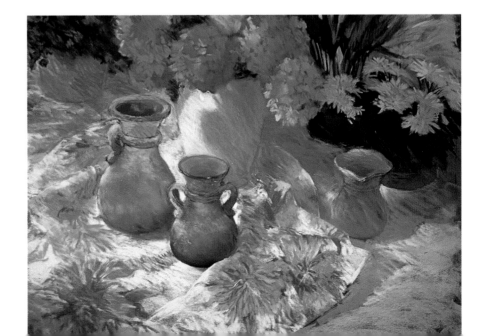

Project

PAINTING WHITE

PAINTING a still life of white objects is an exciting and challenging exercise. It will teach you a lot about tone, and surprisingly about color also, even though you are dealing with objects that are not intrinsically colorful. It is relatively easy to identify shapes when there are strong contrasts of tone or color; for example, if a red object is placed against a blue background you will be able to read the shapes mainly in terms of the local color. But there is little visible local color on white objects because white is reflective, even when matte-surfaced, and picks up other colors. So you will need to look hard to spot the subtle nuances and shifts of color, and mix your paints with care. Use an opaque medium for this; oil, acrylic or gouache.

1 *It is very difficult to assess the variations in pale colors if you work on white canvas or board, so the artist began by laying a flat color over the entire surface. She is to paint in oils on canvas board, but used fast-drying acrylic for the underpainting*

2 *The choice of red for the ground helps her to select the cool blue-grays by providing a good contrast. It also warms the overall color scheme, showing through the thinly applied grays and off-whites.*

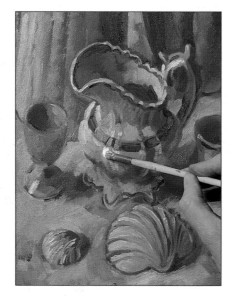

6 *This small highlight plays an important role in describing the fluted sides of the pitcher. It is also the only area of pure white, so the paint is used thickly to prevent it from mixing with the colors beneath.*

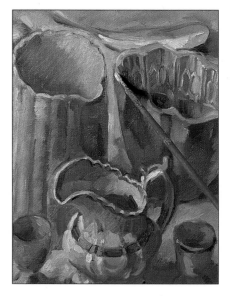

7 *The artist moves from one object to another, comparing the colors and tones, and making continual small adjustments and redefinitions. The edge of the jelly mold is sharpened by taking paint around it.*

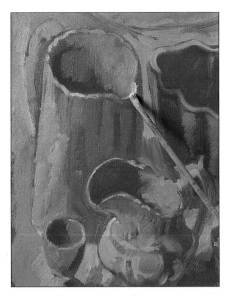

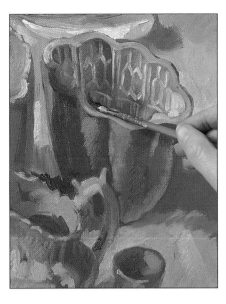

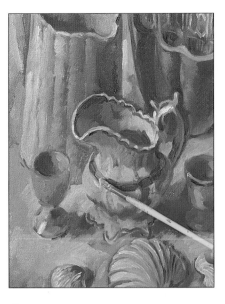

3 *Even these highlights are not pure white. Although she uses white paint, the layers beneath are still wet, and the white is slightly modified by the earlier grays. Notice the variety of colors used on the pitcher alone.*

4 *With the shapes blocked in and the color scheme established, the artist begins to build up the forms with darker paint, used relatively thinly.*

5 *This gold band and the eggcup are the brightest colors in the picture but the yellows need to be judged very carefully; they could easily be made too vivid.*

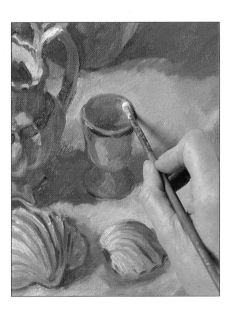

8 *Final definition on the yellow eggcup was left until last, when the pitcher with the gold band, the focal point of the picture, had been completed. A soft highlight is added, with the paint again taken around the shape.*

▷ **Still Life with Victorian Jug**

Ros Cuthbert • oil on canvas board

The finished picture shows the positive role that can be played by a colored ground. The red, although covered with other colors, still makes its presence felt, showing through and between them to create lovely pinks and mauves. Ros Cuthbert has produced a delicate symphony of colors as well as an accurate representation of her subject.

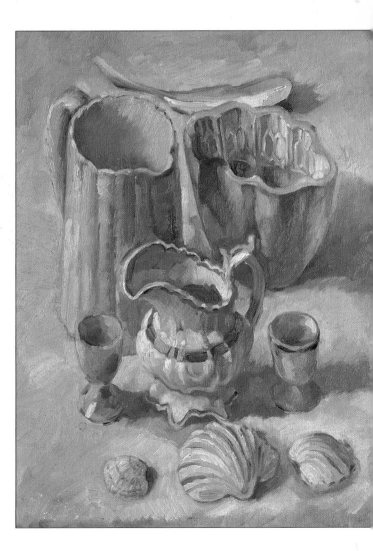

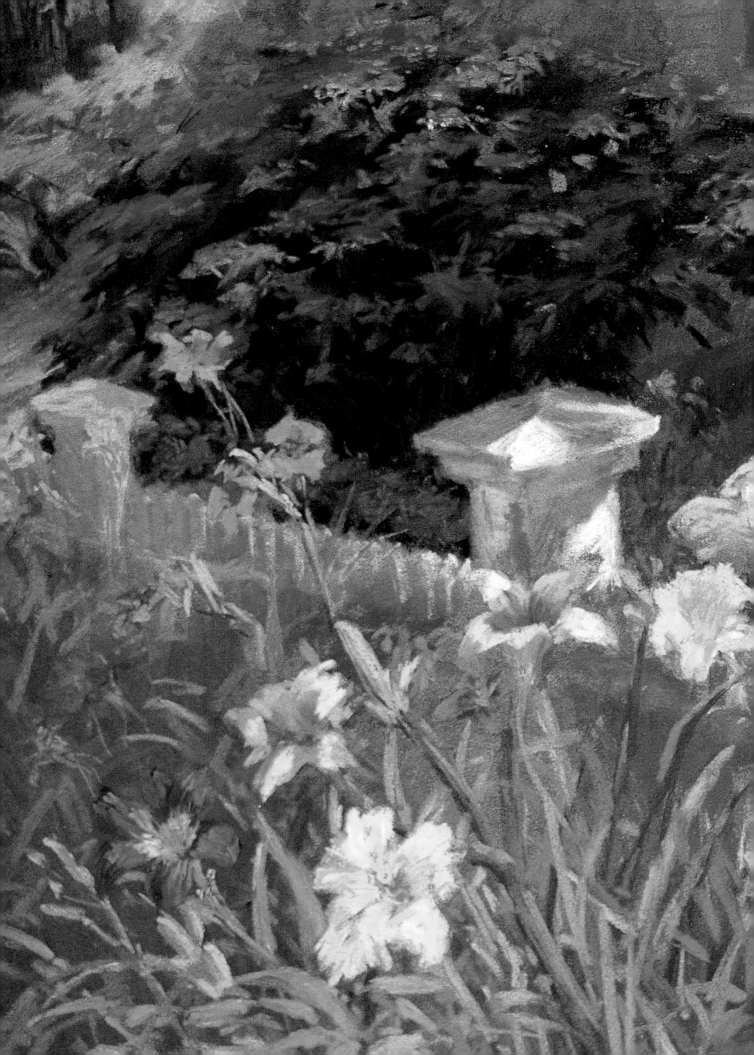

DRAWING & PAINTING METHODS

THIS SECTION OF THE book provides practical advice on painting techniques across all the media – watercolor, oil, acrylic and pastel. If you are a newcomer to painting or have encountered difficulty with a particular medium, the step-by-step demonstrations may give you useful ideas. The section begins with tips on systems of measurement to ensure accurate assessment of shapes and proportions, with particular reference to symmetrical shapes – a stumbling block even for experienced artists.

Checking Shapes

To draw shapes accurately, it is essential to compare one with another throughout the drawing process. It also helps to use some system of measurement

You may by now have discovered that it is not easy to make a good outline drawing, or to get shapes in correct proportion with one another. But there are methods which can improve your observational skills. If you carried out the exercise on page 43, you know how to check the angle of a line, such as the edge of a table, by holding up a pencil, and you can also use a pencil to measure relative sizes.

Suppose you are making a preliminary drawing which includes a tree, and you want to be sure the outline is right before painting. Hold the pencil horizontally at arm's length, slide your thumb along it until you have the overall width of the tree, then turn the pencil to a vertical position and see how many times the width goes into the height. The same method can be used for objects in a still life, where you can check not only the height-to-width ratio of each object, but also their different sizes. This is especially helpful when objects are at varying distances from you, since perspective effects can make it easy to misunderstand size and scale.

Drawing sight size Some artists always make their drawing or painting the same size as what they see – which does not mean the same as drawing life-size. Try the idea of sight size by placing an object on a table and holding up a piece of paper in front of you at the distance you would normally draw from. Then close one eye and make two marks, one for each side of the object. It's a little like drawing through a sheet of glass; objects will be the size they register on your retina.

Drawing sight size is easier than attempting to scale things up or down, which often causes shape and angles to go awry. It even allows you to make precise measurements with a ruler held at the level of your work surface. But it can be restrictive, since it sometimes means you must work on a more limited scale than you would like. If you are painting a figure, for example, and cannot go in close, a sight-size drawing will be too small to allow you to give free rein to expressive line, color or brushwork.

Visual references Whether you work sight size or not, slanting shapes and diagonal lines are always hard to assess correctly unless you have some verticals and horizontals to compare them against. When you draw a table from the front, both sides will be diagonals sloping inward. You can determine the angle of these lines more easily if you look at the legs, which provide a vertical reference. Drawing the table top alone is more difficult, which is why people often get this shape wrong in still lifes.

Pencil measurements *You can check both sizes and angles with a pencil held out in front of the subject. For size comparison, be sure to hold the pencil with your arm completely straight, and to remain in the same position for each measurement. When checking angles, be careful to keep the pencil at the same angle when you bring it down to the paper to mark in your line.*

Checking against straight lines *It is difficult to draw anything in isolation because you have nothing to compare it with. You can judge the curve of a chair arm or the angle of an arm or leg in a figure drawing better if there is a straight line behind or next to it.*

Vertical and horizontal references are particularly useful in figure drawing, because they help you to understand the lean of a body, the slope of the shoulders, or the angle of an arm or leg. Often you can find background features that provide these, such as a door or window frame.

1 *The vertical lines of the wall are sketched in immediately, as they help the artist to assess the angle of the arm. The door behind the figure establishes his size and position in space.*

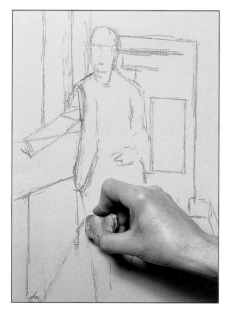

2 *With the outline of the radiator drawn in, the artist looks at the negative shape between it and the leg, and sees that an adjustment is needed.*

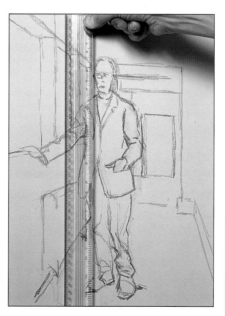

3 *As a further check, a ruler is held up against the figure and then transferred to the drawing. This shows the artist the exact position of the head in relation to the legs and feet.*

The vertical plane *Here you can see the principle of sight-size drawing, with the width of each object ticked off along the top edges of the paper. The board is held vertically, which makes accurate drawing easier. This is because we perceive objects on a plane at right angles to our line of vision, almost as though they were suspended on a sheet of glass. If your board is at an angle or flat on your lap, you have to make difficult mental adjustments, and the bottom half of your drawing may become disproportionately large. (You often see this effect in drawing classes when students sketch on a pad held flat on their laps instead of upright on an easel.)*

Difficult Shapes

SYMMETRICAL SHAPES, SUCH AS VASES,

AND STRAIGHT EDGES – TABLES,

BUILDINGS AND SO ON – OFTEN GIVE

TROUBLE, BUT THERE ARE SOME TRICKS

OF THE TRADE TO HELP YOU

IF YOU HAVE ATTEMPTED still life or flower subjects, you will certainly have encountered the problem of symmetrical shapes, and had to struggle with lop-sided vases and bottles that seem to be falling over. Often you don't notice these things until you have almost completed a picture, when it is too late to do anything about them, so it is worth spending time on the preliminary drawing. It helps to draw a central line from the bottom of the object up through the ellipse at the top, before drawing the outline. Then, if the outline still looks wrong, try taking measurements from the central line to each outer edge; the chances are that you will find a minor or perhaps major discrepancy.

Tracing But the measuring method is not infallible. If you have an object with swelling sides or sloping shoulders, it is difficult to decide which part of the edge to measure to. Exactly where, for example, is the outermost point of the curve?

Here tracing can be a useful aid. If you are fairly confident that one side of the object is right, make a tracing from this side to the central line, turn the tracing over and transfer the lines to the other side, as shown (below). You can adopt the same technique for repeat patterns on fabric, wallpaper and so on, but only if they are on the same plane. Remember

Mechanical aids *There is no reason not to use rulers, tracing paper and so on if they help you make accurate preliminary drawings for painting. Artists through the ages have used drawing aids for subjects that are notoriously difficult, such as buildings and figure drawing.*

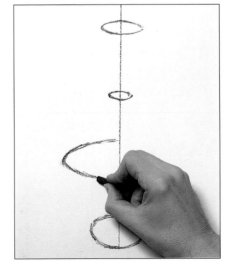

❶ *A pencil line has been ruled from top to bottom, and one side drawn in and measured. This measurement is transferred to the right side.*

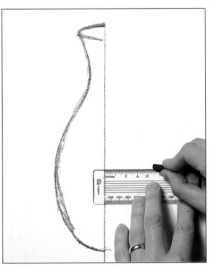

❷ *It is easier to draw ellipses complete, so an alternative is to begin with these, again using a central line to ensure that both sides are equal.*

that on a receding plane the shapes will become progressively smaller because they will be affected by perspective.

Straight lines Wobbly lines for the fronts and backs of tables also let down still-life paintings, and straight lines are of obvious importance in architectural subjects. There is nothing wrong with using a ruler when you make your preliminary drawing; the effect may be somewhat mechanical, but that doesn't matter, because it will be obscured by paint.

It is trickier to maintain a straight edge when you start to utilize color, especially with the opaque media – watercolor is easier to control. If you are using pastels, oils or acrylics, try painting against a ruler or thick piece of paper to give a sharp edge. You can also employ masking methods, which are explained on the following pages.

▷ **White Open Spaces**

Gary Michael • pastel

For a subject like this, where there is no bright color or pattern to interfere with our perception of the shapes, accuracy is all-important. An uneven ellipse or a vessel appearing to topple even slightly would jar the viewer's nerves, destroying the painting's atmosphere of well-ordered calm.

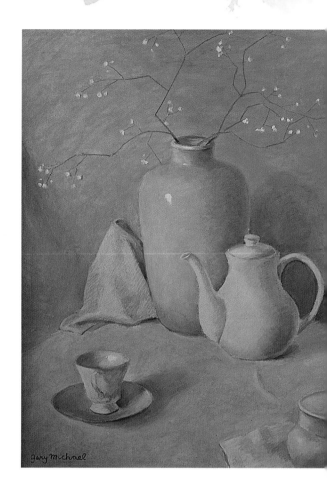

1 *This object with a handle is complex in shape, so the tracing method is used to check the drawing. The artist has traced the left side and is removing the tracing before turning it over.*

2 *With the tracing turned over, repositioned on the central line and held firmly in place, she draws over the lines to transfer them to the drawing paper.*

It can be hard to achieve perfectly straight lines in pastel, so a piece of paper is used as a mask. When removed, the edge will be clean and crisp. The same method can be used when painting.

Masking Methods

Masking tape, cut paper or liquid friskit are all useful painting aids. Tape can be used to keep edges clean and straight, while the liquid is excellent for highlights

MASKING OR DRAFTING TAPE is an extension of the method of painting against a ruler or piece of paper, but in this case you stick the tape to the picture surface. It is not suitable for all of the painting media because it may affect the surface, or not adhere to it properly. You can use it on some pastel papers, but remove it as soon as possible or it may cause damage, scuffing the surface or leaving a residue of glue.

Masking tape adheres well to watercolor paper and comes off easily, so it is satisfactory for watercolor work and acrylic on paper. For oils or acrylics done on a textured surface, such as canvas or canvas board, the method will work provided the paint is used thickly. The tape sticks only to the raised grain and would allow thin paint to seep underneath, giving a blotched edge.

Cut-paper shapes For pastel work, an alternative is a paper cutout, but this is only practical for fairly simple shapes. An example might be a white building outlined against the sky, or a pale still-life object against a darker background. Begin with the negative shapes – sky or background – then cut a hole in a piece of tracing paper for the positive shape, hold it firmly in place on the picture surface, and paint the shape. When the mask is removed, you will see impressively sharp, clean edges.

Liquid friskit (masking fluid) In watercolor painting, highlights and light areas are created by "reserving," that is, by painting around the shape, which can then be left white or filled in with a pale color. Liquid friskit, a rubbery fluid which you paint onto the paper and peel off when dry, is very helpful, especially for small shapes which are tricky to paint around without spoiling. If you mask highlights, such as pale leaves in a landscape, you can work freely, knowing that there is no danger of paint slipping over their edges.

You can achieve fairly intricate effects with liquid friskit, so try to identify the exact shape of each highlight before you apply the fluid. Whether you are using a liquid mask or reserving shapes by painting around them, watercolors need careful planning, so start with a preliminary drawing to place the light areas. And a word of caution: don't leave liquid friskit on the brush for long or it will be impossible to remove from the bristles.

▽ **Bank of the Orinoco**

Hazel Soan • watercolor

It would have been impossible to achieve these fine lines of crisp-edged highlight without liquid friskit (masking fluid). Notice how in places they give the effect of white brushmarks.

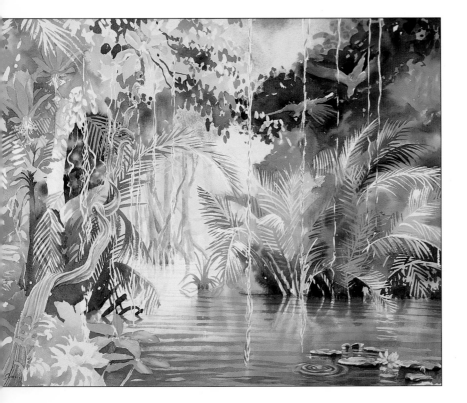

Watercolor *Masking methods are particularly useful for watercolor painting, as they allow you to work freely. If you are constantly worried about paint slipping over edges, your technique may become tight and nervous.*

Pastel *Masking methods are less often used in pastel work, because pastel is an opaque medium, allowing edges to be cleaned up by working light over dark or vice versa. But they are useful on occasion, for example if you want to avoid a heavy build-up of pigment.*

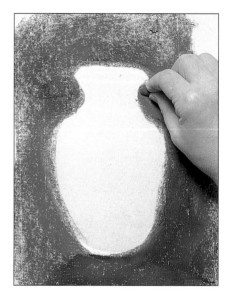

❶ *The background must be finished first and then left alone, as the defining of edges will take place on the object itself.*

❶ *The shape of a house has been masked out with tape, and the first washes of sky color are loosely applied.*

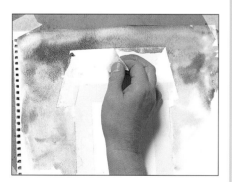

❷ *More color has been dropped in wet-into-wet and allowed to dry before the tape is removed. It is wise to remove the tape as soon as it is practicable, or the glue may harden and spoil the paper.*

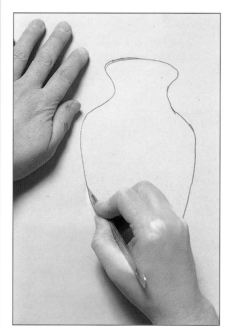

❷ *A tracing has been made of the vase shape, and the tracing paper taped to a cutting board. The shape is cut out with a craft knife.*

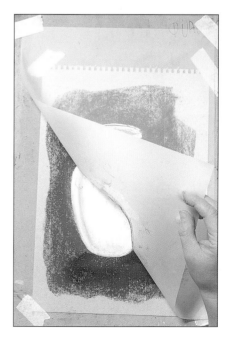

❸ *The tracing paper, with its vase-shaped hole, was taped onto the working surface and the white laid on firmly. It is now carefully peeled back.*

Accentuating Shapes

Keep the shapes and edges fluid in the early stages of your painting. When you have nearly finished, decide whether some of them need more emphasis

As YOU SAW IN Part One, hard outlines destroy form, so once you have begun to paint, think in terms of color and tone rather than line, building up gradually to clearer definition. Stand back from your work often to assess it, and when a picture is nearing completion, see whether you need to bring things into sharper focus by strengthening a shape or crisping an edge here and there.

Increasing tonal contrast If a shape fails to stand out in the way you want it to, it may be because there is insufficient tonal contrast. This can be remedied by applying darker or lighter color for the background – the negative shapes between and around the positive ones. Watercolor is, of course, a transparent medium, so you will not be able to lighten a background color, and might need to darken the positive shapes instead. Alternatively, you could increase definition by additional tonal modeling and a few crisp touches of detail.

Finding lost edges Edges often become lost during the painting process, through accidental smudging, accumulation of pigment or inaccurate brushwork. It is easy to sharpen the image by finding some of these lost edges. In watercolor, oils or acrylics, use a

Oil paints *Because oil paints remain wet for some time, paint can be moved around on the surface to redefine shapes and emphasize edges. It is usual to begin with fairly thin paint and build up gradually to thicker applications.*

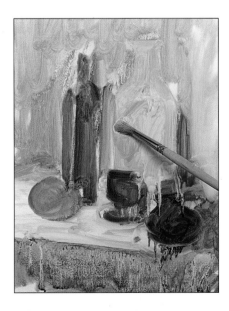

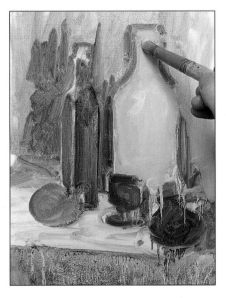

❶ *The artist, working on oil-sketching paper, starts by blocking in the composition using paint diluted with mineral spirits (white spirit) to an almost watercolor-like consistency.*

❷ *The yellow bottle is the dominant shape and needs to stand out sharply from the background. Having used some darker red to outline it, he begins to build up the forms with thicker paint.*

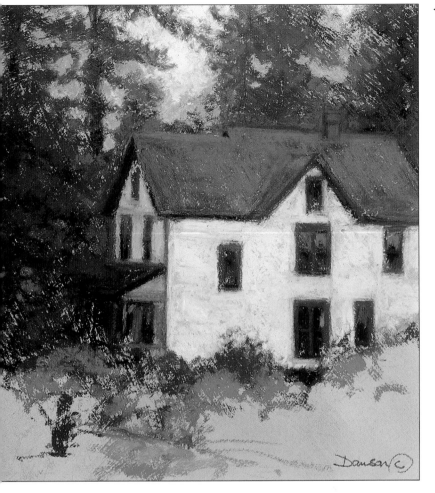

◁ **Near Buffalo Creek** Doug Dawson • pastel

This is a middle-toned painting, with no very pronounced darks; but within this overall framework, the contrasts are sufficient to make the shapes stand out firmly. The artist plans the tonal structure of his paintings very rigorously, judging the value of each color against a gray scale.

small pointed brush in much the same way as you would a drawing implement. In pastel, you can make surprisingly fine lines with the edge of a broken stick.

But don't overdo the hard edges, and consider whether the painting really calls for them. A few highlights added in the final stages may be the only crisping touches you need. Highlights play a vital role in explaining shape and form.

In watercolor you must begin with the light areas, but if you have lost a highlight, you can reclaim it with a touch of opaque

3 *The yellow used for the bottle, mixed with a little green, is taken firmly around the edge of the eggcup to sharpen it, a method known as cutting in.*

4 *Edges and ellipses often become lost in the painting process and need to be redefined. A small brush has been used to redraw the top of the bottle, and background color is cut in around it.*

5 *The process of defining shapes and modeling forms is continuous, and the picture is now virtually complete. A final touch of thick paint emphasizes the bottle's shoulder.*

The oval of the hood within the rectangle of the picture sets up an exciting interplay of shapes. Acting as a frame within a frame, it encloses and accentuates the long shape of the face, with the dark shadow throwing the outline into relief. Although it is a fine and sensitive portrait, the painting can also be read as an abstract arrangement of shapes and tones.

white. For small linear highlights, such as those on the rim of a glass bottle, scratch into the dry paint with a blade.

Maintaining the shapes Sometimes shapes go out of true as you paint; you may find that a symmetrical object begins to look lop-sided. To redefine a shape, or part of it, simply take background color around the suspect edge. This is known as "cutting in."

In watercolor you will only be able to do this if the shape is substantially paler than the background, so if you have gone badly wrong, you may need to adopt one of the correction measures described on page 56.

Pastel *Pastel is a notoriously smudgy medium, and it is always best to reserve detail and fine definition until the final stages. Any fine lines or small highlights put in too early may become rubbed or obscured by later work.*

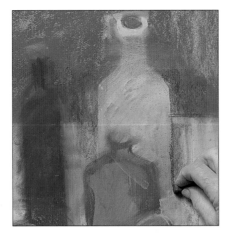

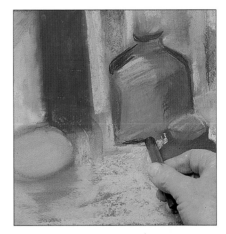

❶ *The objects were painted before the background, and have become soft and smudged, so the artist begins to sharpen up the image. Here she uses the tip of a dark pastel stick.*

❷ *A very dark blue is chosen to define the bottom of the green glass bottle, with the same blue used on the shoulders. There are often strong tonal contrasts on glass objects.*

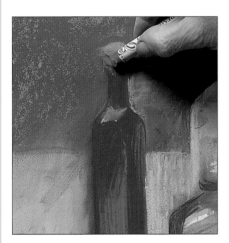

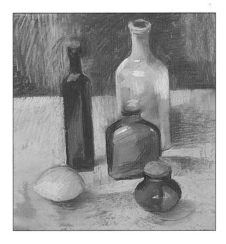

❸ *It is difficult to make very precise or fine lines with soft pastel, but a touch of lighter blue is all that is needed to suggest the highlight on the rim of the bottle neck.*

❹ *The artist now turns her attention to the tablecloth, where she needs some strong color to balance those of the objects. For this shadow, she uses a piece of paper as a mask to prevent the color from slipping over onto the bottle.*

❺ *The final stage was to deepen the background color, particularly the area behind the pale bottle. There are strong tonal contrasts throughout the painting, making the shapes stand out firmly.*

REDUCING DETAIL

YOU can sometimes give your painting greater impact by reducing the amount of surface detail. This allows each shape to be read easily because there are no inessentials to distract the eye. These three paintings, although very different in style, all show some simplification, and have strong tonal contrasts that accentuate the shapes.

For this approach to be successful, it is important to identify the main shapes and make them as descriptive as possible. In Joyce Zavorskas's painting, for example, the outline of the pools portrays not only the flat planes of the water, but also the forms of the surrounding land and the recession of the landscape. In the harbor scene, the shape made by the boat and its reflection show the angle at which it rests in the water and its height above the water.

Although the hillside is initially perceived as a flat shape, there is just a hint of the separate forms, with a darker area at the bottom and a patch of sky peeping through arches at the top.

The shared edge where pinkish brown meets green follows the slight swell of the land. The two colors are very close in tone to avoid a jumpy transition, with brushstrokes of slightly darker tones suggesting surface variations.

△ **Quiet Place on the Pamet**

Joyce Zavorskas • monotype

In spite of its gentle colors, the painting makes a considerable impact, deriving from the arrangement of the shapes. The pale water is counterbalanced by the midtones of the encircling land and the darker hillside on the left. Although there is little detail, there is enough to play a descriptive role. The small reflections in the water on the left reinforce the shape of the grassy mound above. The foreground grasses explain the type of landscape as well as providing textural contrast for the glassy expanse of water.

Slight shifts of color, from mauves to pinkish browns, enliven the immediate foreground, but detail was reserved for the grasses. The textured effect was achieved by scraping into wet paint.

The shape of the wall was precisely described through the outline of the highlights – the lighter line at the top and the zigzag of the steps.

The far wall is in deep shadow but this catches some reflected light from the water, revealing the texture of the stonework. The artist used slight tonal variations while avoiding excessive detail.

The large ripples curving above the boat are an important part of the composition. To enable him to use broad, sweeping brushmarks, the artist painted the ripples first and applied a light brownish wash on top for the reflection.

△ **Dalkey Harbour**

Bryn Craig • watercolor

In the previous painting the light shape was dominant, while here the eye is drawn to the dark forms of the harbor wall and building, and the smaller shape of the boat. Again detail was minimized: the side of the boat was merged into its reflection, the seaweed in the foreground was suggested with squiggling brushmarks, and the top of the right-hand wall was marked only by a strategic line of highlight.

If color contrasts are too strong, the picture may lack unity. The artist introduced yellow into the background and foreground to provide a visual link with the yellow book on the left.

Strong tonal contrast with the background makes this shape stand out, but the eye is also caught by the deliberate distortion of one shoulder higher than the other and a sharply pointed foot.

Shapes painted very flatly can look dull, but here the entire painting is energized by the pastel strokes. Horizontal strokes over diagonals give this vase solidity.

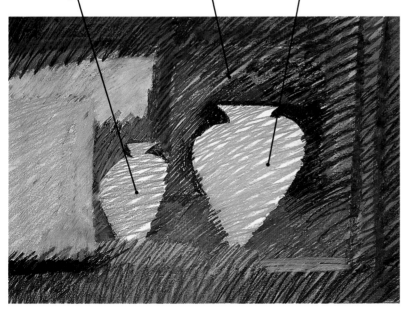

◁ **Two Pink Vases**

Paul Powis • oil pastel

This painting is much more abstract than the other two, with the shapes more dramatically simplified. The artist took existing objects as his starting point, but did not attempt to treat them realistically; there is no suggestion of form or texture. But if you compare the three paintings, you will see obvious similarities; in each of them the primary interest is in shapes, colors and tones, and their interaction.

Blending Methods

I N ROUNDED FORMS AND MANY

LANDSCAPE FEATURES, SUCH AS CLOUDS,

HILLS OR MASSED TREES, COLORS AND

TONES APPEAR TO MERGE WITH NO

PERCEPTIBLE BOUNDARIES

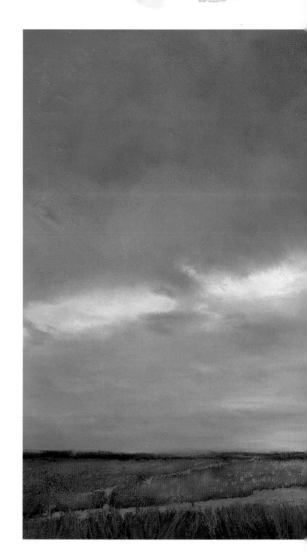

YOU DON'T HAVE TO paint exactly what you see, and to some extent the medium dictates how you "translate" the real world. Watercolor and acrylic, for example, both naturally produce hard edges, and later we shall be looking at ways of exploiting these characteristics to introduce a deliberate "edginess" into your work. But sometimes the most intriguing aspect of a subject is the subtle gradations of tone and color, and you may want to match these effects in paint by using blending techniques. However, bear in mind that too much blending can result in a dull image, so the methods described below should be used with discretion.

Pastel Pastel is a soft, crumbly medium, prone to smudging, so it is easy to rub colors together and into the paper surface. Begin by applying color with the side of the pastel stick to achieve an even coverage, then rub the pigment lightly with your hand, a rag or a cotton ball. For small areas there are special blending tools called tortillons, or you can use cotton swabs, an inexpensive alternative.

Because pastel pigment is so readily moved, you tend to lose a good deal of the color when you rub it, especially if you use a rag or cotton ball. Hand- or finger-blending is less wasteful: due to the slight greasiness of skin, more color is rubbed into the paper. But for dark, rich colors the best method is over-laying and blending with the pastel sticks themselves. If colors become too thick to be workable, spray the surface with fixative between layers.

Oils Oil paints can also be moved around the surface, since they remain wet for some time, so it is not difficult to create gentle gradations. The brushes and the consistency of the paint are both important factors. Thick oil paint applied with bristle brushes will create a series of separately visible marks. You can avoid this (if you want to) by using soft brushes – sable or synthetic – and thinning the paint slightly with linseed oil or an alkyd medium. As in pastel work, fingers are a good blending tool and are often used for softening an occasional edge or merging brushmarks.

Watercolor and acrylic These two media seem very different, but they have two things in common. Both are water-based, and both

Blending oil paint *Oil paint is a versatile medium which can be used in varying consistencies and applied in a number of ways. Many artists like the way it holds the marks of the brush and exploit this characteristic, but if you want soft blends, it can be made more fluid by the addition of an alkyd medium.*

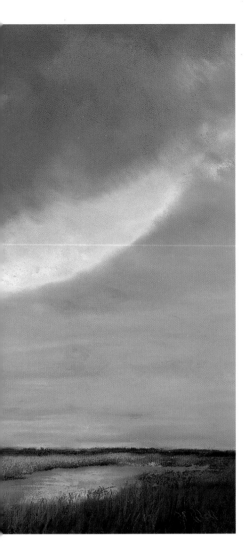

△ **Summer Light** Lois Gold • pastel
Blending has been used for the sky both to create soft effects and to increase the depth of color in the sky; the more layers of pastel, the stronger the color. The brilliance of the band of cloud prevents the painting from looking over-soft.

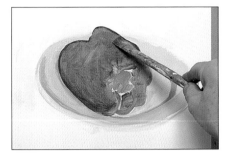

1 *The paint has been thinned with a mixture of alkyd medium and turpentine, and is applied with a nylon brush. These are specially made for acrylic work, but can also be used for oils.*

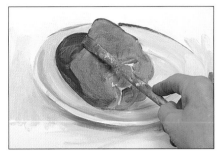

2 *Darker color is added with the same brush. You can judge the fluidity of the paint by the fact that it does not completely cover the color beneath.*

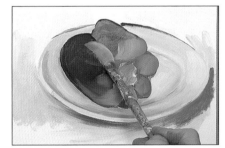

3 *Lighter greens are applied and blended into the dark areas on the left where the yellow/green/red pepper is turned away from the light.*

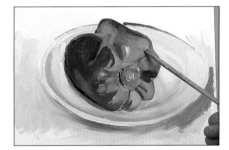

4 *The artist continues to build up the forms, working from dark to light. Although brushmarks are visible, the effect is softer than that of unthinned paint applied with bristle brushes.*

dry rapidly, making blending methods more problematical than with oil paints.

Left alone, a watercolor wash will dry with a hard edge when wet paint meets dry paper, so the secret is to keep softening these edges as you work, using a brush damped with clean water. A related method is to work wet-into-wet, explained on the following pages, but this is not ideal for the highly controlled gradations you need for building up forms.

An over-hard edge in watercolor can be softened with a damp sponge or brush even after it has dried, but when acrylic is dry it can't be moved. The thinner the paint, the faster it dries, so blending is easiest with thick acrylic, and you can slow the drying time further by adding retarding medium. If you like to use acrylic thinly on paper, try dampening the paper slightly in the area to be blended.

Removing Paint

FOR SOFT-EDGED PALE SHAPES SUCH AS

DIFFUSED HIGHLIGHTS, PAINT CAN BE

"LIFTED OUT" WITH A SPONGE, AND

FINE LINES CREATED BY SCRATCHING

INTO THE PAINT

LIFTING OUT IS A watercolor technique that follows the same principle as softening edges with a damp brush or sponge. You simply dab a small sponge or a piece of absorbent paper into a wet wash. This sucks up the paint, giving you a diffused white shape.

Lifting out is the easy answer to painting clouds, and it enables you to create a number of effects. For example, a sponge taken rapidly across a blue wash in a diagonal sweep will suggest high windclouds, while crumpled paper dabbed irregularly into the wet paint will give the impression of the tops of cumulus clouds. If you then add a little gray into the bottoms with the paper still damp,

the illusion will be complete. For the small, soft highlights you might see on a piece of fruit or matte-surfaced vegetable, use a brush or a cotton swab in the same way.

Scratching As we have seen, sharp-edged highlights can be created with liquid friskit (masking fluid), but this is too thick to achieve the fine lines of highlight that you sometimes see on foreground features such as the edges of leaves. Here the best method is to wait for the paint to dry thoroughly, then scratch into it with the point of a blade.

This technique, known as sgraffito, is also used in oil painting, though more often to convey texture than to create highlights, and usually when the paint is still wet. You can achieve fine highlights by scratching into dry oil paint, but for this to be successful the overall paint application must be thin; fine white lines among brushstrokes of thick paint would look out of place.

Blotting and scraping Both these techniques are restricted to oil paints, and both are ways of softening an image or parts of it. The first,

Watercolor clouds
You have seen how you can create white shapes in watercolor by using masking tape or liquid friskit (masking fluid), but these methods are less suitable for clouds because they result in hard-edged shapes. The lifting out technique is ideal, producing soft edges and highly realistic cloud shapes.

❶ *The artist dabs a piece of crumpled paper towel into the still-wet blue wash. The paper lifts the paint unevenly, leaving small patches of blue behind.*

❷ *After lifting out clouds all over the sky, she begins to add color, dropping in blobs of dark gray. The paper is still damp, so the brushmarks spread out.*

Scraping off oil paint *Applying paint and then scraping it down with a palette knife can create intriguingly diaphanous effects and textures that are very different from paint applied in the usual way. Working in oil, the artist has blocked in the landscape broadly, using the paint quite thickly.*

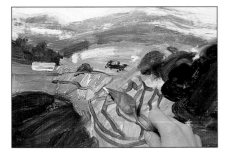

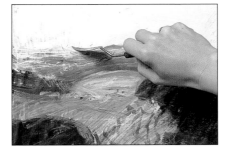

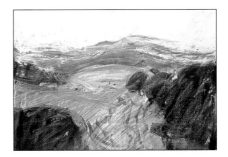

1 *She now begins to scrape the paint away from the central area of hills, using the knife so that it follows the direction of the contours; you can see the full effect of these lines in the next step.*

2 *Some of the paint has been removed from the hills, and the knife is now used to pull the light paint for the sky downward, perhaps suggesting cloud or a squall of rain.*

3 *There is no detail in the painting, but the combination of brush and knife work suggests the shapes and forms of the hills and trees very well, and the picture has a strong sense of atmosphere.*

known as tonking after its inventor Sir Henry Tonks, one-time professor at London's Slade School of Art, involves blotting the top layer of paint by placing absorbent paper over the entire surface, rubbing with the hand and then removing the paper. It is primarily a remedial measure, a way of making an overloaded surface workable, but it is useful for subjects such as misty landscapes and portraits of children, where you want to minimize detail and edges.

The second method is to scrape away the top layer of paint with a palette knife. This is better than tonking for selective areas of a picture because it gives you greater control. You might scrape the background of a still life or the sky in a landscape, for example, leaving the rest of the painting intact.

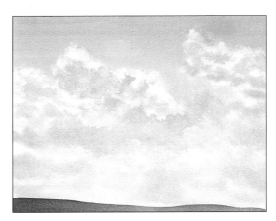

3 *The crumpled paper is used again to remove some of the dark color and soften the transitions of tone. Care is taken to preserve the white edges of the clouds.*

4 *The effect is extraordinarily lifelike. The tops of the clouds are soft, but in the middle, where the gray paint has spread out and dried, you see the ragged edges.*

Wet-on-Dry

Working in a series of layers, and allowing each to dry before the next is applied, is a traditional technique for oils and watercolors

Before the time of the French Impressionists, the standard manner of painting with oils was to establish a monochrome underpainting and build up the colors gradually in a series of thin, transparent layers called glazes. This was slow, because each glaze had to dry before the next was applied, and it was therefore not a suitable method for recording the fleeting landscape effects which were the Impressionists' main interest. They rejected it in favor of the *alla prima* approach, in which the painting was completed in one session, with no underpainting, and wet colors were often applied over and into adjacent colors.

Acrylic Nowadays the majority of oil painters work *alla prima*, but many of the traditional oil-painting methods have been adapted to acrylic. This medium dries rapidly, so unless you use it thickly with a retarding medium, you will nearly always be working wet-on-dry.

The effect of successive veils of thin color is entirely different from those of opaque paint. Each new glaze modifies the color beneath but does not completely cover it. It is an ideal method for building up forms through subtle gradations of tone and color, and is also useful for modifying colors. If the distance in a landscape looks too bright, you can simply lay a blue or gray glaze over it. The paint can be thinned either with plain water or a mixture of water and acrylic medium.

Watercolor Watercolors have to be worked in layers, because it is impossible to achieve great depth of color with a single application. Unless you use wet-into-wet methods (explained on the following pages), you begin with pale washes for the lightest tones, which are left to dry before further washes are

Watercolor wet-on-dry *The hard edges created as brushmarks or washes dry are part of the medium's charm, and working in this way allows you fully to exploit the marks of the brush.*

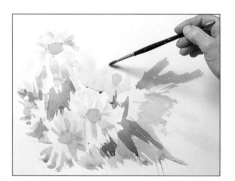

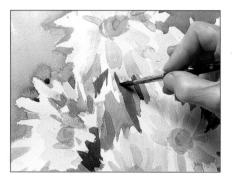

❶ *Each leaf or petal is painted in one stroke of the brush, the marks kept separate so that they do not flow into one another. The yellow flower centers were put on after the petals had dried.*

❷ *The colors become darker and richer as the painting moves toward completion. Here, a deep blue-green is laid over a paler shade of the same color, and on the left you can see a similar area of overlaid brushmarks.*

◁ **A Conference of Pears**

Ronald Jesty • watercolor

This artist works almost exclusively wet-on-dry, and plans his paintings carefully in advance, making a full preliminary drawing so that he knows exactly where to place each color. There is just a touch of controlled wet-into-wet work on the pears, where tiny blobs of paint applied with a pointed brush have been run together.

painted on top, gradually building up from light to dark.

Each wash or brushmark is a small pool of color, and if left alone, it will dry with hard edges. As we have seen, these can be softened if desired, but they are often exploited, not only to describe the actual shapes and edges, but also to add an element by letting the medium "do its own thing." If you have the chance, look at some reproductions of watercolor landscapes by Paul Cézanne, and you will see how differently shaped brushmarks and small washes create a series of little curved or straight lines that give the picture a lively shimmering quality.

Glazing with acrylic *Acrylic can be thinned with water, or a mixture of water and acrylic medium, and built up in a series of transparent layers over a monochrome underpainting.*

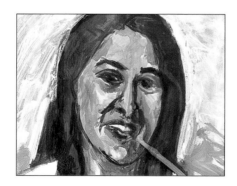

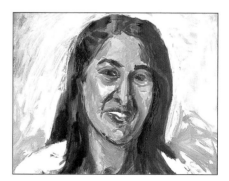

1 *A deep purplish red was chosen for the underpainting, to blend in with the sitter's warm golden-brown skin. A transparent orange-brown has been applied on top over the hair and is now used on the face.*

2 *The artist has deliberately left areas of the underpainting showing through the glazed colors. Notice that it now looks more strongly purple, because of the juxtaposition with the vivid yellow.*

Wet-into-Wet

EXCITING EFFECTS CAN BE CREATED

IN WATERCOLOR BY WORKING ON

DAMP PAPER OR INTO STILL-WET

WASH SO THAT COLORS FLOW

INTO ONE ANOTHER

SOMETIMES ENTIRE PICTURES, MOST often landscapes, are built up in a series of wet-into-wet washes, but it is more usual to combine wet-into-wet with wet-on-dry methods, because this gives more contrast in edge quality. Also, wet-in-wet is much harder to control over large areas than when it is restricted to certain shapes.

Wet-into-wet is primarily a watercolor technique, though any oil painting completed in one session will be painted wet-into-wet to some extent, simply because the paint takes a long time to dry, and artists do exploit the medium's slow drying time to blend colors and soften edges. Acrylic mixed with retarding medium can be used in much the same way.

How watercolors behave But watercolor wet-into-wet is different. Although there is a common belief that it is a way of mixing colors on the papers, this is not strictly true. With oil paints you can blend wet colors on the picture surface by pushing one into another just as you would on the palette, but in watercolor the mixes will be only partial.

Painting a fresh color over a wet one is like dropping a stone into a pond; the weight of the water in the new brushstroke pushes the previous color away. The colors bleed but retain their individual identities.

Another aspect to understand is that the colors will go on moving, pushing outward, until they have dried, which is what makes the method both exciting and frustrating. An effect that looked wonderful at first may alter before your eyes, and there is no way of keeping it.

Degree of wetness

The effects of this method depend on how wet the paper is and how much water is used to dilute the colors. With practice you can learn to control it.

❶ *The paper has been very thoroughly dampened and two bands of strong color painted on. Notice how the paint begins to spread out immediately.*

❷ *The board was tilted slightly to encourage the dark gray to flow into the blue, and then left to dry flat. The bands of color have spread out and diffused.*

Controlling the edges *You can choose any area to paint wet-into-wet simply by dampening the paper selectively. There will be a crisp edge where the flow of paint is halted by dry paper.*

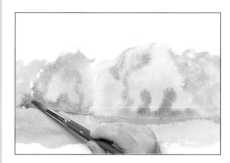

1 *The paper has been dampened with a brush in the area of the trees and grass, and colors dropped in over one another.*

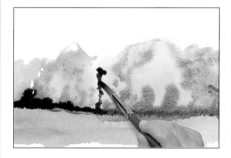

2 *The paper has now dried slightly, so this dark paint spreads less dramatically. If the paper becomes too dry, redampen with a wet brush.*

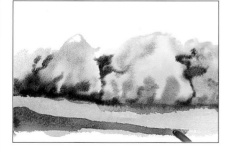

3 *The first wash for the foreground grass has now dried, allowing a shadow to be added wet-on-dry to make the image crisper.*

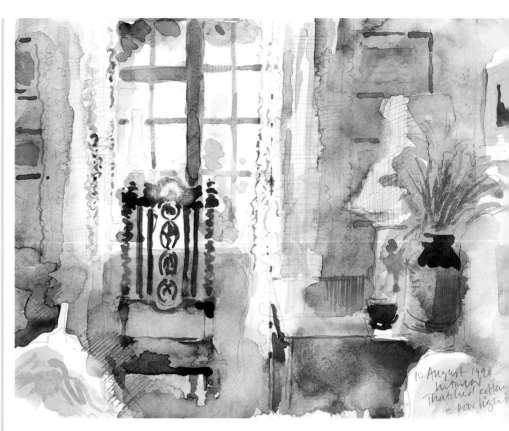

△ **Interior, Thatched Cottage**

John Lidzey • watercolor

A carefully controlled use of wet-into-wet methods can be seen in this painting. On the side and top of the table, indigo and yellow were encouraged to flow into one another, but without running over the edges of the white shape beneath the bowl. The outer edges of the plant, where wet paint has met dry paper, are crisp, an effect echoed on the left of the picture, where pools of paint have been left to dry untouched. The chair and various other details were painted wet-on-dry.

Selective wet-into-wet Although all the colors on the damp surface will continue to move, they won't flow over onto any areas of dry paper. They will stop dead, drying with a hard edge, so that by dampening only the area of paper within a shape, you can create a distinct outline. If you then want to work wet-into-wet for the background as well, let the shape dry and dampen the paper up to the edges; this will preserve the crispness of the edge.

You can achieve fairly accurate descriptions of form once you have learned to control the paint. One way to do this is by tilting the board so that the color flows up, down or sideways. Another is by judging the degree of dampness of the paper correctly – this will come with practice. The stone-into-water effect is most pronounced when a lot of water is present; you have more control if you work on just-damp paper with relatively dry paint.

Brushmarks

THE SHAPE, SIZE AND DIRECTION OF THE MARKS YOU MAKE WITH YOUR BRUSHES OR PASTEL STICKS CAN HELP YOU DESCRIBE THE SHAPES AND EDGES OF THE OBJECTS YOU ARE DEPICTING

IN THE OPAQUE MEDIA – oil, acrylic and pastel – directional strokes are often used to suggest form. Brushmarks or pastel strokes curl around a shape such as a tree trunk; more sweeping strokes follow a flat plane such as water or a table top; and gentle curves convey swelling hills or human limbs.

Directional strokes over large areas are less easy in watercolor – because it is such a fluid medium, brushstrokes tend to flow into one another. But you can use one-stroke touches of the brush for small shapes such as leaves or flowers, or create the impression of massed foliage by a series of little marks.

Carpenters sometimes say you should "let the saw do the work," which means going with the tool rather than against it, and in painting you can "let the brush do the work." Whatever medium you are using, check out all of your brushes to see the shapes of stroke they can make. In pastel, experiment with various marks – from long sweeping side strokes to short curving ones made with a small piece of pastel.

When you are tackling a real subject, bear in mind the size of the brushmarks. Just as objects appear to become smaller the farther away they are, so must the marks you use to describe them; otherwise, you will lose all sense of space in your painting (more about creating space on pages 88–91). So if you are painting a field of flowers, or a landscape dotted with trees, make the marks progressively smaller as the flowers or trees recede from you.

Expressive brushmarks *It is not easy to disguise the marks of the brush when using oil paints, so it is best to make a feature of them. One of the medium's many charms is its buttery consistency, which allows you to make your brushwork an important and integral part of the picture.*

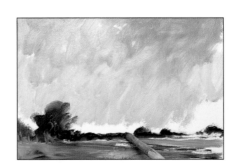

❶ *The artist is working on oil-sketching paper, a non-absorbent surface which allows paint to be moved around and manipulated. He uses bristle brushes and has thinned the paint with turpentine.*

❷ *A dark gray is laid over the earlier blue, with swirling and crisscrossing brushmarks that suggest the movement of the sky.*

Directional strokes *Like brushmarks, pastel strokes should be viewed as part of the picture; they are not just a means of laying on color. They can be both expressive and descriptive; for example, they may follow a form to suggest it so that you can use less tonal modeling.*

1 *The grapes in the foreground have been modeled mainly in tone, but with the highlights curving around the shapes. Here a small length of pastel is used to make short, thick curving marks.*

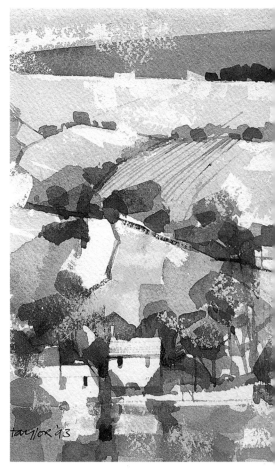

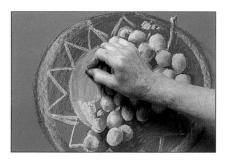

2 *Again, side strokes are used to curve around the inner edge of the plate. The artist is mixing her colors on the paper by laying red over yellow.*

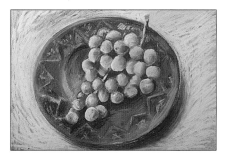

3 *She has varied her strokes to create a lively effect, contrasting long, sweeping curves with short, energetic, almost scribbled marks and diagonal hatching.*

△ **East Fellside Landscape**

Bill Taylor • watercolor

This artist works wet-on-dry so that the small pools of color that comprise each brushstroke retain their crisp edges and show the shapes of the brushes used. Rather than laboriously building up the forms of the trees and hills with blending methods and variations of tone and color, he uses a firm one-touch stroke for each separate shape, overlapping in places to create a lively network of marks that describe the landscape with great economy of means. In the foreground, he has scumbled gouache paint over the watercolor: notice how it catches only on the raised grain of the rough paper, suggesting a sparkle of sunlight.

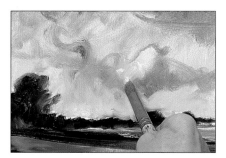

3 *He continues to build up the sky with bold strokes and now lays in creamy white for the cloud top. Because the paint remains wet, each new color mixes slightly with those below, creating a soft effect.*

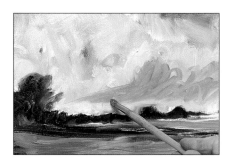

4 *The underside of the cloud is given more shape and form with rapid strokes of mid-gray. At top left, you can see how the paint has been moved around on the surface, with the original dark gray dragged downward.*

Analysis

PAINT CONSISTENCY

EACH of these three paintings shows the artist's interest in brushwork, not only to describe forms, shapes and textures, but to contribute to the composition and overall feeling of the picture.

They also provide an interesting insight into ways of handling the painting media. Two of the pictures are oils and one is a watercolor, yet because the oil paint was used exceptionally thinly in *Dalbrack*, it has more in common with *Environs of Pamajera* than with the other oil painting, *Summer Shade*. It is always worth experimenting with paint consistency. Mediums are available for thickening or thinning oils and acrylics, and additives such as soap or gum arabic can make watercolor hold the marks of the brush.

The brushstrokes for the sky above the umbrella change direction slightly so that they frame the painting's dominant shape.

The directional brushstrokes allowed the artist to describe the dress very economically, with minimal tonal contrast and variation of color.

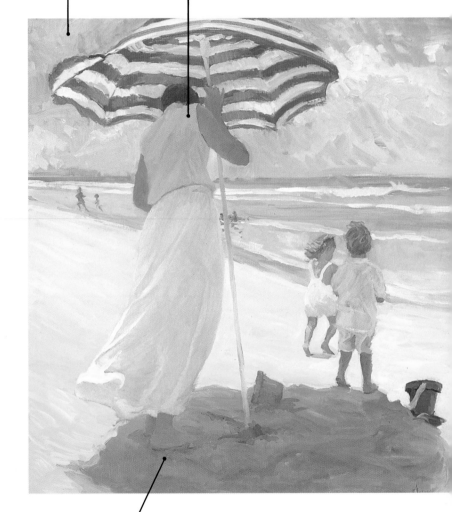

△ **Summer Shade**

Denise Burns • oil

Because oil paint is a "buttery" medium, the brushmarks will almost always show, so it is essential to figure out how they can be used to best advantage. Here they are mainly directional, following the folds of the clothes and the undulations of the water. In the sky they are loose and energetic, conveying the movement of windblown clouds – the children's hair, the dress and the spray flung from the waves confirm the weather conditions.

This area is important to the composition, balancing the shape of the umbrella. The brushstrokes are varied, both to create interest and to suggest the trodden sand.

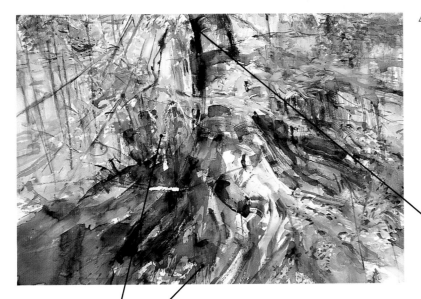

△ **Environs of Pamajera**

Alex McKibbin • watercolor

The artist produced a wonderfully lively interpretation in which the brushwork is an integral part of the composition. Instead of building up colors and tones with overlaid washes in the traditional watercolor manner, he used strong colors from the outset, applying each brushstroke rapidly and leaving it alone.

The form is described by the way the brushmarks curve around the tree trunk. To achieve a gradation from dark to a midtone, the artist began with a loaded brush, drawing the paint out toward the center.

Varied brushmarks in yellow and green depict the leaves, some downward-curving and others more horizontal. Patches of white paper were left to suggest the play of light.

Paint was flicked on and left to dribble down the paper or to form small pools. Notice the brilliance of the colors used to make up the overall grayish hue of the trunk and roots.

The marks curve slightly around the tree trunk, suggesting both the form and the texture of the bark.

Brushwork here forms a pictorial link with foreground and gives a generalized impression of more trees and foliage.

The brushstrokes, each one composed of a series of fine lines, follow different directions to describe the tufts of grass.

▷ **Dalbrack** James Morrison • oil

In this detail, this artist's oil painting technique is very different. He dilutes the paint heavily with turpentine and linseed oil, and works on a smooth-surfaced panel, which does not absorb the paint as canvas will. Instead of a homogeneous brushstroke, you can see the marks of each separate hair, giving an intriguing striated effect that expresses the grass and tree trunks perfectly. Because the paint is so thin, the white of the surface shows through to give the luminous effect associated with watercolors.

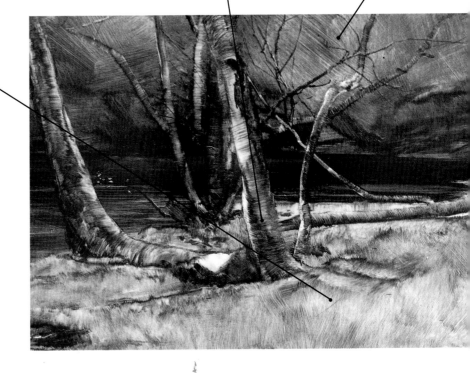

Knife painting *If you have not tried painting knives, they may sound clumsy implements in comparison with brushes, but actually they are surprisingly malleable. The blades are made of thin, flexible metal, and several different shapes and sizes are available, for effects from broad to very fine.*

❶ *The artist is using undiluted acrylic and flicks the petal shapes onto the paper with a small triangular knife. He has first laid an area of blue to help him judge the colors needed for the flowers.*

Impasto Techniques

Working with very thick paint gives extra emphasis to your brushwork, and you can use the medium itself to convey shapes and edges in the subject

IMPASTO IS THE WORD used to describe paint applied thickly enough – either with a brush or a painting knife – to stand out slightly from the picture surface. You can only create impasto effects with oils or acrylics; pastel can be applied heavily but not in true impasto manner, and watercolor is obviously not a candidate for this treatment.

The effect of impasted paint is almost like that of relief carving; the marks of brush or knife form a series of edges where the raised paint throws a tiny line of shadow. These can be a means of producing a lively picture surface (we look at this aspect of picturemaking on pages 120–121), but they

can also imitate the real edges in the subject. For example, if you paint each leaf of a tree, or the petals of a flower, in a separate stroke of thick paint, they will be clearly defined. This is particularly useful where there is little tonal contrast in the subject.

The raised-edge effect is most obvious when you apply the paint with a knife, since the blade squeezes the paint onto the surface, resulting in a flat plane with ridges at the edges. Painting knives are available in many different sizes and shapes, and are capable of surprisingly delicate effects.

Thick and thin Some paintings are done in impasto throughout, exploiting a pattern of brush- or knife marks over the entire surface; Van Gogh's paintings are the best-known examples of this approach. But impasto can be reserved for certain areas of a picture, which not only gives an interestingly varied surface but also helps to accentuate shapes. Thick

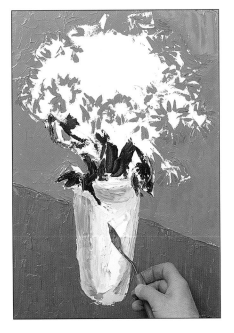

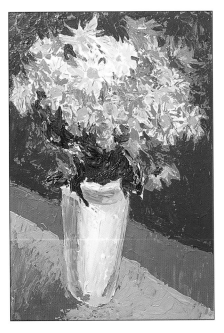

2 *The paint has now been thickened with gel medium, which bulks it out considerably, and is taken carefully around the edges of the vase.*

3 *The vase must be painted with care since the brown paint for the tabletop is still wet. Although acrylic dries relatively fast, it takes some time when this thick.*

4 *The flowers were then completed, and deeper blues applied on the background to contrast with the pink and white. Notice how the light catches on the raised ridges of paint, giving the painting an exciting edgy quality.*

◁ **Path to Heligan, Mevagissey**

Don Austen • oil

This painting shows a confident use of the impasto method. At the top of the picture there is almost no tonal contrast, yet individual leaves are clearly discernible because of the lines of light and small pools of shadow created by the knife-applied paint.

paint makes its presence felt, and will always advance to the front of the picture. You could make the shapes in a still life or flower piece stand out from the background merely by contrasting thick and thin paint. Similarly, if you use touches of knife impasto for flowers or grass in the foreground of a landscape, there will be no doubt about their position in space.

Mediums Oil paint can be used at tube consistency for impasto effects, but for any but a small area this can become very expensive, so you would be wise to mix your paint with one of the special impasto mediums. These bulk out the paint so that you need only a fraction of the amount. Several types of bulking medium are also sold for acrylic. Most acrylic paints are runnier than oils, though consistency varies between brands.

Making Alterations

The painting process involves continual assessment of your work, so stand back from it frequently to judge whether you need to redefine shapes or alter colors

Some of the painting media are more difficult to correct than others, but a degree of alteration is always possible. Don't proceed with a picture when you can see that things have gone wrong; be prepared to make changes and corrections as you work.

Oil paints It is usually easy to alter a still-wet oil painting, but if there is a heavy buildup of paint, you may need to remove some of it before reworking. Scrape down the area you want to rework with a palette knife, or to remove the paint even more thoroughly, rub it off with a rag dampened with turpentine or other paint solvent.

You can make corrections to a dry painting by overworking, provided the paint has not been used too thickly. Solid applications of paint give a pronounced surface texture which is difficult to work over.

Watercolor This medium has a reputation for being difficult to correct, but it is not impossible. Just as edges can be softened

Correcting a watercolor *Watercolor will allow some degree of alteration, but it is seldom possible to reclaim the pure white of the paper. Keep a tube of opaque white, either Chinese white or white gouache paint, in case you need to make the kind of corrections shown here.*

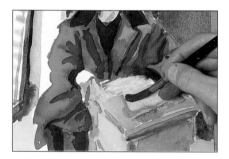

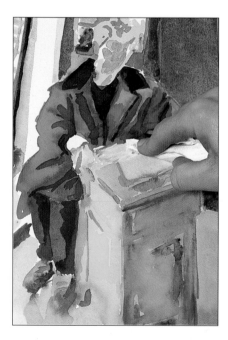

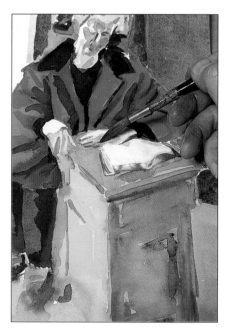

1 *The artist has decided that the book on the desk top needs more emphasis. Working carefully within the outline of the shape, she lifts out some of the yellow paint with a wet brush.*

2 *The area is now blotted with paper-towel, which takes off more of the paint as well as surplus water. The color cannot be removed completely, as it has stained the paper.*

3 *The pages of the book have been painted with opaque white, and the darker edges with pure watercolor. Final touches of definition are given to the hand.*

with a damp sponge, you can wash out entire shapes or areas of the painting. The success of washing out depends on the color. Certain colors contain dyes that stain the paper and can't be removed completely. If you intend to overpaint in a darker color, this may not matter, but if the new color is too light to cover the stain, mix it with a little opaque white – Chinese white or gouache paint. This is also useful for reclaiming lost highlights.

Acrylic Acrylic paint can't be moved once dry, so it is seldom possible to scrape down, but you can make alterations by overpainting. However, unless the new paint is really thick, you can't always completely cover a dark color with a lighter one; the "ghost" of the wrong shape or edge will show through. In such cases, block out the whole area with opaque white, leave it to dry, and then rework.

Pastel You can do a good deal of overworking in pastel also, but the surface of some of the lighter pastel papers becomes clogged if you put on too many layers of color. If this happens, brush down the area with a bristle brush, or flick it with a rag, then spray with fixative before reworking.

In the early stages of a pastel painting, you can erase to a limited extent with a putty eraser. Don't rub heavily, because this will push the pigment into the surface – dab gently to pick up the pastel dust. You can use the eraser also to clean up edges and lift out color for soft highlights.

Correcting an acrylic painting *Although acrylic is an opaque medium, it has less covering power than oil paint, and new colors do not completely hide what is beneath unless the paint is very thick. It you want to make radical changes, overpaint the area in white before applying the new color.*

1 *Midway through the painting, the artist decided to change the shape of the flag. As the sea went in, it became apparent that it should be flying.*

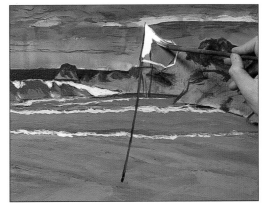

2 *He makes a brush outline of the new shape and then fills in the whole of it with thick white.*

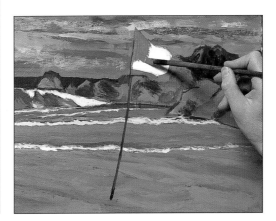

3 *Without the layer of white, some of the red now applied would have sunk into the sky color, reducing its intensity.*

WORKING WITH WATERCOLOR

A GOOD watercolor painting has a freshness and luminosity of color that few of the other painting media can rival, but to achieve these qualities, it is important to plan the picture in advance. It is not enough to lay on colors randomly and try to alter them as you go along, hoping that a painting will emerge in time. This is likely to result in tired-looking paint and muddy colors which sacrifice the very qualities that make watercolor so attractive. The artist has exploited the unpredictable effects produced by the wet-into-wet method, which gives the work a delightful feeling of spontaneity, but it is a "planned spontaneity," with her knowledge of the medium informing her procedure at every stage of the picture. She uses a hairdryer to halt the flow of the paint where she wants hard edges, but for softer effects she leaves the colors to dry naturally.

1 *To provide all-over ground color, a very pale blue wash is laid with a sponge, dried with a hairdryer, and followed by an equally pale pink wash.*

2 *A deep, rich blue is then dribbled on at the top over a loosely painted pink wash, and the board is tilted so that the paint flows downward. You can see the effect of this in Step 3.*

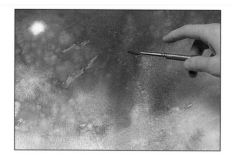

6 *Having covered all of the paper and established the basic color scheme, the artist now returns to the sky. The paint is still damp, and water is flicked onto it to produce a series of backruns. You can see the effect clearly around the moon.*

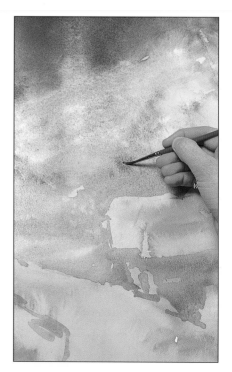

7 *She now continues to build up the middleground, where she wants cool colors to contrast with the vivid foreground yellows. The trees are touched in with cerulean blue, which mixes with the wet yellow to produce blue-green.*

5 *The paper was dampened around the tops and sides of the houses, so that their edges remain crisp. In this area, wet-into-wet is again used, with cerulean blue dropped into the pinks and yellow.*

3 *The pink and blue have run into each other, with more pink visible toward the bottom of the paper. With the paint still wet, the moon is lifted out with a ball of absorbent cotton.*

4 *In the foreground, cadmium yellow has been applied over the still-wet pink. A backrun is encouraged by dropping in paint from a loaded brush.*

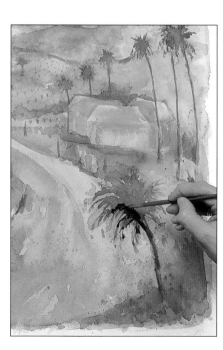

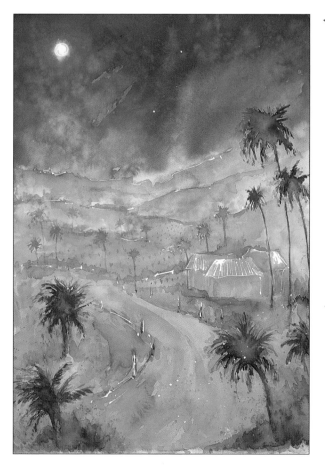

8 *The palm trees are worked wet-on-dry, with a hairdryer used between stages. On the left you can see the backrun formed earlier (see Step 4), which provides a shape to balance the tree.*

◁ **Jaquaraka Tinqua Banana Plantation**

Annie Wood • watercolor

One of the potential dangers of working wet-into-wet is that the shapes may become too soft and amorphous, but here a nice balance has been struck between suggestion and precise description. In the final stages of the painting, all the palm trees were redefined, and white gouache was used to strengthen the shape of the moon and make fine highlights on the roofs, fence posts and the tops of the hills.

WORKING WITH OILS

OIL paint can be applied in a number of different ways. Some artists like to build up thick, impasted surfaces, while others use their paint thinly throughout. Whatever your preference, bear in mind that thin paint should never be applied over thick, because this can cause cracking with time. The commonest method, which the artist followed here, is to begin with thin paint, diluted with turpentine, and build up gradually to thicker paint with a higher oil content, using the paint most solidly in the highlight areas. This helps to create a three-dimensional effect, since thick paint has a more obvious physical presence than thin.

1 *The artist colored the canvas with a light ocher – another traditional oil-painting method – and began with a sketchy brush drawing to place the head.*

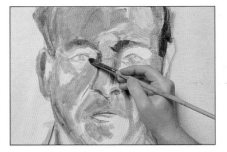

2 *For the first layers of color, she diluted the paint heavily with turpentine so that you can see the grain of the canvas. She uses bristle brushes.*

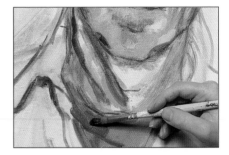

6 *To preserve the unity of the picture, the artist chooses similar colors for the shirt and the face. She applies greenish brown over the orange.*

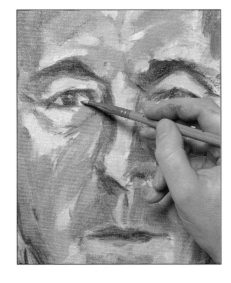

8 *It is essential to leave final definition of the eyes until the planes of the eye socket and cheekbone are fully established.*

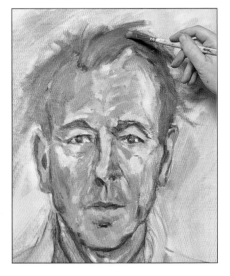

9 *To suggest the soft and windblown hair, the artist sweeps the brush upward and outward to meet the paint of the background, avoiding a hard boundary.*

3 *The face has now been more firmly drawn with brushstrokes of blue-gray and brown, and the artist gradually begins to build up the skin colors.*

4 *At this stage the paint is used more thickly. A pale pink is applied to the brows, nose and upper lip.*

5 *It is easy to make alterations while the paint is wet. A finger softens the line of the bottom lip and blends colors into one another.*

7 *The paint is still diluted, but now with linseed oil rather than turpentine. This makes it creamier than the blue-gray on the sides of the nose.*

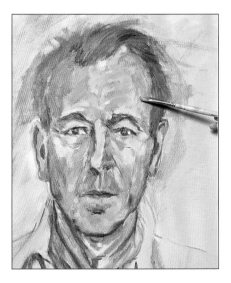

10 *Very thin paint is used again for the shadow at the side of the temple. Thin paint tends to recede, while thick paint advances to the front of the picture.*

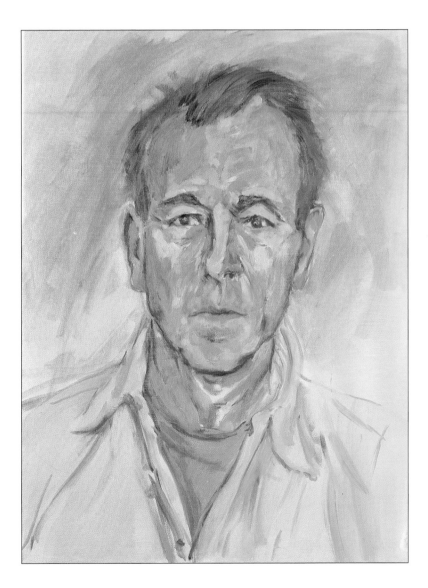

△ **Portrait of Anthony** Rima Bray • oil on canvas
Through lively brushwork and thoughtful paint handling, Rima Bray has avoided the static look sometimes seen in full-face portraits. Her treatment is impressionistic, in that she has not dwelt on details, but the face and clothes are convincing portrayals of three-dimensional forms.

Demonstration

WORKING WITH ACRYLICS

ACRYLIC is possibly the most versatile of the painting media. It can be applied in varying consistencies, with bristle or soft brushes, and you can paint it on more or less any surface that is not greasy or glossy – watercolor paper, canvas, canvas board and masonite are all commonly used. While sharing some of the qualities of oil paint, acrylic dries much faster. This means that you cannot move paint around on the surface to any extent. But the short drying time facilitates overpainting and glazing methods, allowing you to make continual changes as you proceed with the picture.

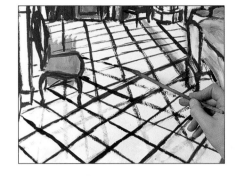

❶ *Working on watercolor paper, stretched to prevent it from buckling when wet, the artist begins with a brush drawing and some patches of diluted color. He takes particular care with the complex perspective of the tiled floor.*

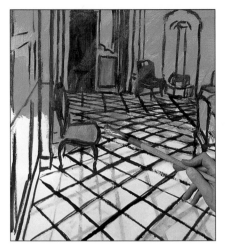

❷ *He lays a glaze of strong but thin color (diluted with water) over the entire painting surface to set the color key for the picture. The drawn lines show through this transparent layer.*

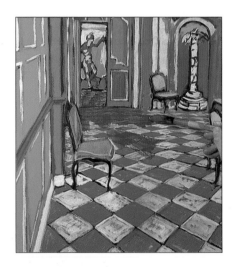

❻ *On the side wall and door, reds were painted over the orange underpainting, and the artist can now view the floor in the context of the other colors. He darkens it by laying a glaze of diluted paint with a soft brush.*

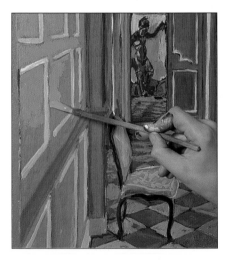

❼ *Painting is a continual process of assessing one color and tone against another, and after darkening the floor the artist decides to introduce further colors into the wall. A layer of vivid pink over the red is the first step.*

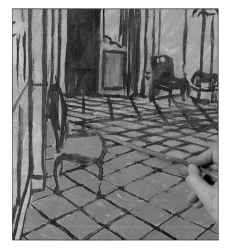

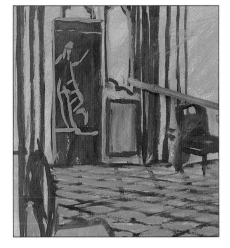

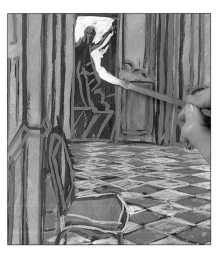

3 *Now he begins the process of building up the real colors of the subject. The blue-gray paint is applied more thickly, but he deliberately leaves small lines and patches of the underpainting visible.*

4 *These edges are important, because they enclose and define the interesting shape of the door panel. The blue used earlier for the floor is applied firmly with a long-handled round bristle brush.*

5 *Further work was done on the floor, with white tiles painted over the blue. Thick white paint is now used to block in the negative shape between the statue and the door.*

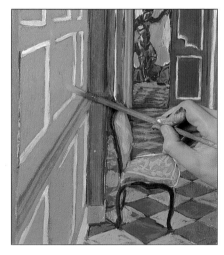

8 *The pink was intended as a base color, and is now overlaid with an orange similar to that of the original underpainting. Some of the pink is left to peep through, creating a sparkling broken-color effect.*

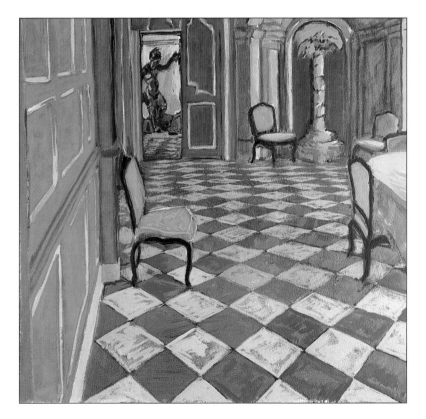

△ **Interior, Villandry** David Cuthbert • acrylic on watercolor paper
The finished painting shows why it was necessary to tone down the blue and white tiles with a gray glaze. The color scheme in David Cuthbert's painting is based on red and yellow, and an over-emphatic blue could have reduced the impact, particularly of the yellow shapes. This muted gray-blue complements them perfectly and prevents the tiled floor from dominating the painting.

WORKING WITH PASTEL

THE immediacy of this medium makes it especially appealing, and it is becoming increasingly popular with both amateur and professional artists. When you use pastel, you are drawing and painting at the same time, applying colored marks direct to the paper with no premixing. You can apply flat blended areas of color, lay one color over another to achieve subtle or rich mixtures, and vary the marks you make to build up a lively picture surface. As you saw on pages 76–77, it is relatively easy to make corrections without detriment to the painting, so there are none of the fears and inhibitions associated with watercolor work. But too much overworking can produce a clogged surface, muddy colours and indistinct or untidy edges, so it is always wise to work out the composition and placing of the shapes in advance, as the artist has done here.

1 *The artist has chosen a dark paper on which she first made an underdrawing in charcoal. She then blocked in the pale tones, using light pressure to avoid filling the paper grain.*

2 *The houses outside the window are treated initially as flat pattern, with each area of color worked separately so that the edges of the shapes are crisp.*

6 *Although pastel is crumbly, fine definition can be achieved with the edge of the stick or a sharpened tip. Black is now cut in around the scallops to emphasize the edge by means of tonal contrast.*

7 *The skull needs a sharper, darker edge to make it stand out from the buildings outside the window. Charcoal, which pairs well with pastel, is used to outline the shape.*

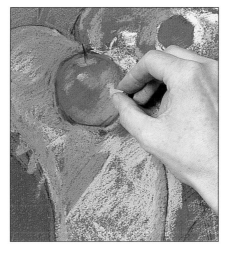

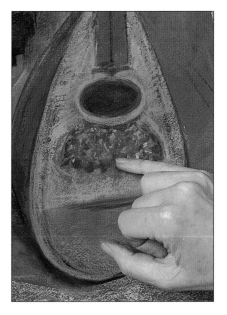

3 *As she works, she assesses one color and tone against another. With the orange-browns of the mandolin and rooftops established, she can decide on the red needed for the pattern on the cloth.*

4 *To give unity to the picture, she uses the same or similar colors in different areas. The red of the apple echoes the tablecloth, and now a highlight picks up the pale mauve of the plain cloth.*

5 *For the pattern of inlaid wood on the mandolin, short, jabbing strokes have been made with the point of the pastel stick, and are now lightly blended in places with a fingertip.*

9 *The sky has been modified with an overlay of white, and now yellow ocher is used, applied lightly enough for the blue to show through. The colors mix optically to produce green.*

8 *The effect of overlaid color can be seen clearly in this step and the following one. First two shades of blue are laid over the area of sky above the houses.*

▷ **Spanish Still Life** Rosalind Cuthbert • pastel
The finished painting shows how a controlled and thoughtful use of pastel can create lovely color effects, a variety of edge qualities and precise definition of shapes and forms. You can also see the part played by the paper color, which shows through the pastel strokes to become a color in its own right.

Part Three

PICTURE-MAKING

GOOD DRAWING AND CONFIDENT handling of your chosen media are both important skills, but they are only part of the painting process. The artist must give equal consideration to composing the picture, creating a sense of three-dimensional space, and using both color and brush or pastel marks expressively. The text offers general advice on these topics, while the selection of finished paintings and step-by-step demonstrations provide inspiration and ideas. Two special analysis features focus closely on selected paintings, with captions and annotation highlighting the artists' pictorial concerns and methods.

White Street Jill Mirza • acrylic

Our eye is led from the front to the back of the picture by the diagonals of the roof lines and the sweeping curve of the dark shadow. This arrangement is very satisfying.

Creating Space

Painting a picture is visual

trickery – you are creating the

impression of three dimensions on

the flat surface of a canvas

or piece of paper

△ **Fort Bragg** LaVere Hutchings • watercolor

The perspective effects are carefully observed in this acccomplished painting. Notice particularly how the waves become smaller as the plane of the sea recedes, until the choppy water on the horizon is represented simply by a broken line. The strong contrasts of tone used for the foreground rocks mean that they come forward to the front of the picture plane.

EVEN BEFORE THE LAWS of linear perspective were formulated in the 15th century, artists sometimes created convincing spatial effects. They could see, just as we can, that objects became smaller and smaller the farther away they were, and they trusted what their eyes told them. But perspective is our main means of creating the illusion of three-dimensional space, so you may find it useful to turn back to page 42, where you learned about the effect of perspective on sizes and shapes. Whatever you are painting there will always be some perspective involved.

Perspective effects can also make your picture more dynamic. A curving path or river snaking from foreground to background will make a series of fascinating shapes of its own as it gradually thins to a thread, breaking up the ground area into larger shapes. A straight highway running from the foreground to the distance in an expanse of flat country will form an elongated triangle, contrasting with the less defined shapes of land or sky. It will also emphasize the space by seeming to invite the viewer into the picture.

Atmospheric perspective There is another kind of perspective that helps you put things in proper position in space. This is known as

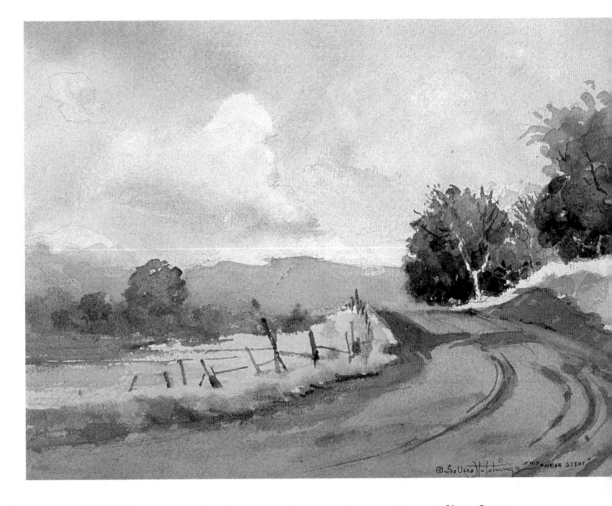

▽ **Oceans Apart**

Hazel Soan • watercolor

In a bright Mediterranean light, the effects of atmospheric perspective are not obvious, but they are still present. The details of the farthest buildings are less defined than those on the boats, and the colors are softer. The vivid blues and strong tonal contrasts used for the furled sails and water distinguish foreground from middle distance.

atmospheric or aerial perspective, and is particularly relevant to landscape painting. It is a phenomenon most people will have observed without really thinking about; you can't see any clear detail in far-off things. Distant hills, for example, will often be no more than flat pale blue or gray-blue shapes.

If you estimate the effects of atmospheric perspective correctly, you can give the impression of recession in a landscape by this means alone, even when a scene presents no obvious linear perspective effects. The first aspect to observe is how distance affects edge qualities. The closer something is to you, the more sharply defined are its edges – you are seeing in sharp focus, and will perceive not only crisper edges but also more detail and stronger tonal contrasts. In the middle distance a group of trees may seem to merge so that you can't pick out individual contours. The overall outline will be softer the farther away the trees are, and the tonal contrasts are progressively reduced. Unless you want to draw attention to something in the middle

△ **Near Stent**

LaVere Hutchings • watercolor

Space is created in this painting by the use of cool blue-gray for the distant hills, and soft wet-into-wet blends for the trees on the left. But far more powerful is the effect of perspective. We are almost propelled into the scene by the sharp curve of the road and the line of the fence posts.

△ **Where the Spotted Owl Flew**

Doug Dawson • pastel

The artist has deliberately limited both his palette and his tonal range in order to convey the peaceful feeling of this woodland, but the colors used for the foreground area are warmer than the greens, blues and pale mauves of the foliage beyond.

distance and make it the focal point of the picture (we look at the idea of focus on the following pages), you should reserve the sharpest edges and strongest tonal contrasts for the foreground.

Warm and cool colors The other effect of atmospheric perspective is to alter colors, and this is more difficult to assess unless you understand one of the important properties of color: its "temperature." Bright colors, such as reds, oranges and yellows, or any mixture which contains these colors – red-brown, yellow-green and so on – are known as "warm," and they appear to push forward to the front of the picture. Any colors with a blue content are "cool," and tend to recede.

Atmospheric perspective causes colors to become both cooler and lighter in tone the farther away they are, which is why distant

hills look blue. The difficulty comes in judging the exact degree of cooling and paling. It's the old problem of being unable to clear your mind of preconceptions. You "know" that a tree in the middle distance is the same color as one in the foreground; you would describe both as green – but the differences will actually be quite pronounced, with the far-off tree more blue than green.

Learning to mix the colors correctly also takes practice; a color that seems right on the palette may look far too dark or bright as soon as you put it on the painting surface because you are now seeing it in the context of other colors. It's important to realize that no color exists in isolation, and color temperature is relative. Blue, although theoretically cool, will only recede if there are enough warm colors to contrast with it.

▷ **Beach Scene**

Alan Oliver • acrylic

Technically speaking, blue is a receding color, but by carefully orchestrating his colors, the artist has made sure that the blue chairs and windbreak come forward. Most notably, he has muted the reds so that they do not compete with the vivid blues, and he has introduced touches of bright blue.

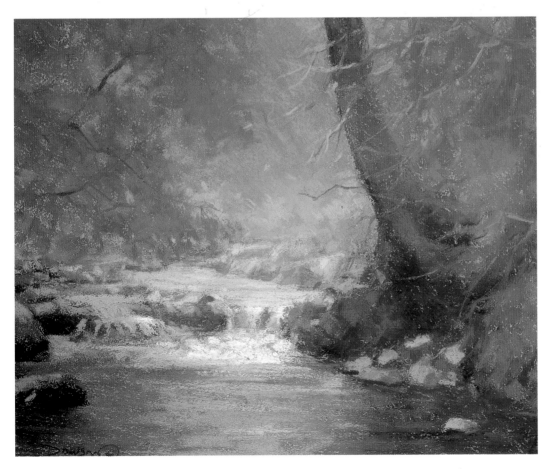

△ **Fall on the Flatland** Doug Dawson • pastel

Here, the bright patch of water and grass in the center draws the eye and leads in from foreground to background, but warm-cool contrasts have also been used. The yellow-green of the left-hand tree stands out against the cooler gray-green, even though both colors are close in tone.

CITYSCAPE

YOUR choice of viewpoint is an important element in creating a sense of space. The great 19th-century French landscape painter Corot always preferred a distant view of his subject, with no immediate foreground, because it allowed him to simplify forms. This artist followed the same practice. He depicts the city from a hill above, with a clear view over the dome and minarets to the farther side of the valley. He works in gouache, an attractive medium which can be used both thinly and opaquely. The surface is cardboard.

1 *The best way to use gouache is to begin with thinned paint. The artist lays loose washes and draws into them with a pointed sable brush.*

2 *He has now introduced sufficient color into the foreground to judge what he needs for the distant hills – a cool gray-green.*

6 *Whites, yellows and rich blues were used at the top of the sky. On the horizon the tone and color contrasts are less marked, calling for quieter grays.*

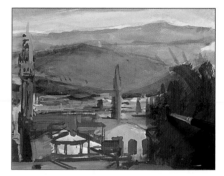

7 *Moving to the front of the painting, the artist blocks in the dark tree in the foreground. In Step 10 you will see how he later amends this.*

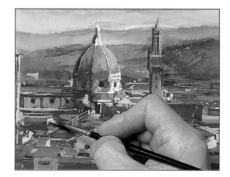

11 *The small white shapes formed by the sides of buildings catching the light are also important to the composition, because they lead in toward the dome.*

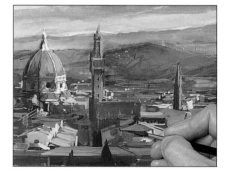

12 *A fine pointed brush, held at the ferrule for maximum control, is used for the slender line of shadow.*

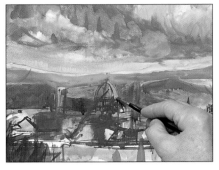

3 *Slightly thicker paint, mixed with white to make it more opaque, is used for the sunlit side of the dome, which is lighter in tone than the hills.*

4 *The strong light picks out the ribs clearly. This area needs firm definition to make it stand out.*

5 *A pale wash of blue-white is applied to suggest the layered effect of distant hills. Unlike watercolor, gouache can be worked light over dark.*

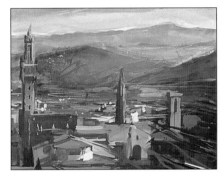

8 *Unless used very thickly, gouache tends to sink into earlier colors. The line of the roof became lost and needed strengthening.*

9 *A little light-colored paint slipped over onto the shadows side of the minaret to spoil the crisp edge, so this is rectified.*

10 *The artist now sees that the foreground tree was too obtrusive, so he overpaints with diagonal strokes that lead the eye inward.*

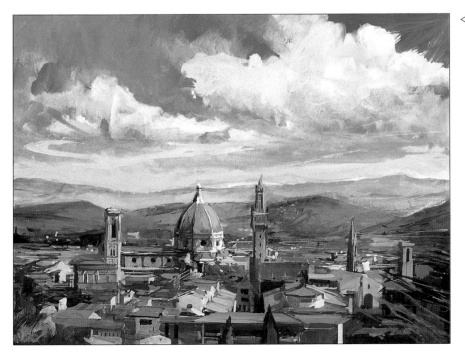

◁ **The Duomo, Florence**

David Carr • gouache on cardboard

The painting derives much of its strength from the deliberate suppression of all unnecessary detail. David Carr has reserved the crispest definition for the central area of the picture around the dome, which is the obvious focal point. On the right and left the buildings are more lightly suggested, and buildings behind the dome are merely hinted at. The warm reds of the buildings, the large area of sky and the cool colors used for the far hills all combine to create a wonderfully spacious impression.

Choosing the Focus

Any painting subject offers a bewildering array of visual information. The artist has to sift out the unnecessary and decide what to focus on

△ **Forget Me Not, Forsythia** Rosalie Nadeau • pastel

The point of focus here is quite obvious, with the sunlit white house standing out both because it is the lightest tone in the painting and because our eye is always drawn to regular geometric shapes. But to guarantee its place as the picture's focal point, the artist has avoided any degree of detail in the foreground, treating the flowers as broad masses of color, with a few light suggestions of individual flowers and leaves. The way the blue shadows on the house echo the blue of the flower clumps and sky, links all the areas of the picture together, so that it forms a harmonious and satisfying whole.

Anyone who has taken photographs knows that unless the scene is sufficiently distant the camera can't focus on everything at the same time. If you take a picture of a person in the foreground of a landscape, you must decide what is important, the figure or the trees, fields and hills beyond, and set the focus accordingly.

To some extent it is the same with painting, but while the camera "sees" from a fixed position, we unconsciously pan around with our eyes, focusing first on one part of a scene and then another, so that there is a tendency to treat foreground, background and middle ground with equal emphasis.

An instructive exercise is to hold up a pencil and focus on that. You will still be aware of background objects, but you will register them only as shapes and areas of color, with little or no detail. If you then shift your focus to the objects, you will see the pencil as a blur. Remember this when you plan your painting, because it will help you to decide where you want the main focus, or center of interest, to be.

Selection Here the analogy with the camera ends, because you can do what the camera cannot – you can sift out inessentials from the many things you see, and stress what is most important to your picture.

Because you have decided to focus on one area doesn't mean that you must paint every feature within it – over-attention to detail can have a weakening effect. Instead, you could use stronger contrasts of tone, or place the most vivid colors in this area; either will draw the eye no matter how broadly the shapes themselves are treated.

Nor does emphasizing a center of interest necessarily call for obvious out-of-focus effects elsewhere, though you may sometimes want these. For example, if you are painting a windowsill still life with a view

△ **Sun Valley ID**

LaVere Hutchings • watercolors

Because the artist has taken a relatively distant view, everything is in equally sharp focus, just as it would be in a photograph. The center of interest, the sunlit patch of road and telegraph poles, is subtle, but the strong tonal contrast between the poles and wire and the blue hills claims immediate attention and draws us into the scene.

▷ **Going for Pizza**

Doug Dawson • pastel

This is a very clever piece of composition. The sharpest focus is on the lettering, which not only explains what the picture is about, but also draws attention to the shadowy figure below. The lettering performs a further compositional function, providing a tonal balance for the light behind the figure and the smaller points of light at top right.

through the window, you would need to "tone down" the glimpse of the outside world to prevent it from stealing attention. You could deliberately blur edges, or simply suggest sky and land with a few light brushstrokes of green and blue.

A subtler version of this approach in a still life or flower painting would be to place a patterned cloth in the foreground or background. This could be suggested more broadly than the flowers or any patterns on the objects, utilizing slight shifts of color and tone with no hard boundaries between them. The crisper-edged shapes of the objects would then stand out and take their center-stage position. If they fail to do so, try increasing the tonal contrasts in places.

▷ **Pink Cyclamen in a Glazed Pot**

Maureen Jordan • pastel and acrylic

Very subtle out-of-focus effects have been used for both the tabletop and the background, with the sharpest definition reserved for the flowers, leaves and pot. The suggestion of pattern in the background forms a pictorial link with the flowers, but because the colors used are close in tone, it does not create a jumpy or obtrusive effect.

◁ **Top Hat** Doug Dawson • pastel
Strong contrasts of tone always stand out, and we immediately focus on the girl's pale face and black hat. The arm and hands play a role in leading the eye up the face.

Signposting Another pictorial stratagem is to use the subsidiary elements in the composition as pointers to the main action. In landscape you can often lead the viewer's eye to a center of interest in the middle distance by means of a path, a stream, the furrows of a plowed field or lines of newly mown grass running in from the foreground. Beware of strong horizontal lines in the foreground; these have a tendency to lead the eye across the picture and straight out of it at both sides.

In a still life or flower painting you can arrange drapery so that it creates diagonal folds leading inward to the center of interest, or you might have some smaller objects, such as fruit, in a roughly diagonal line – don't make your signposts too obvious.

In a portrait you could draw attention to the face, which is your natural point of focus, by including part of an arm or hand, perhaps showing the sitter with chin on hand so that the viewer's eye travels upward to the face. Whatever your subject, always think about how you can orchestrate the various elements so that the painting forms a coherent whole.

◁ **Terrace with Geraniums**

Nick Harris • acrylic

Except on the foreground wall, the edges are all equally crisp. The focal point is obvious, however. Our eyes travel along the walls to the blue-domed building framed by the dark landscape.

▷ **Complementing Colors**

Rosalie Nadeau • pastel

Some of the background colors have been blended together to create a soft blurring, but it is the colors that bring the flowers into sharp focus. As the picture's title implies, these are complementary colors.

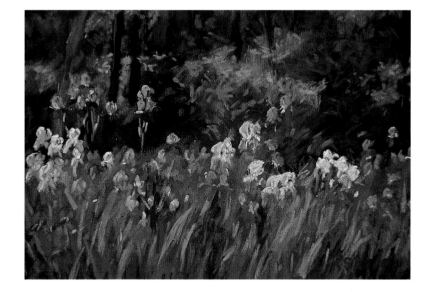

FLOWER PIECE

A STILL LIFE or flower group provides a good vehicle for exploring the idea of focus. In a landscape you may not be able to see much detail in the far distance, so you would choose a natural point of focus in the foreground or middle-ground. But in the relatively small space of a room setting, you can see both background and foreground equally clearly, so you will have to make decisions based on the painting itself, and consider the best way of interpreting reality. The artist has made sure that the flowers are the focal point of the picture by treating the background very lightly, with a minimum of detail, and using slightly cooler colors than those of the flowers and vase. She is working with hard and soft pastels on watercolor board, and begins with an underpainting in watercolor.

1 *Watercolor is laid over a very light underdrawing in hard pastel. Rather than deciding on the format in advance, the artist likes to compose as she works, sometimes extending the picture, hence the blank paper at each side.*

2 *Too thick a build-up of soft pastel can clog the paper surface and reduce the purity of later layers of color, so she brushes over the pastel with water, which acts as a fixative and spreads the color.*

6 *The light greens which suggest the trees outside were earlier on in the painting washed over with water to soften them. Now the window frame, an important element in the composition, is brought into sharper focus.*

7 *The nearest flower is given more emphasis with squiggles of soft white pastel. The very soft pastel is reserved for the final stages, since it is impossible to work over it, and there is also a danger of accidental smudging.*

8 *Having completed the flowers and put in a soft-pastel highlight on the vase, hard pastel is used to draw a firm line for the side of the table, which helps to bring the arrangement forward in space.*

3 *To check the composition and decide whether the format is satisfactory, she holds a thin picture frame up against the work, sometimes keeping it in place as she draws.*

4 *Throughout the working process, hard and soft pastels are used in combination, depending on the edge quality required. The outlines of the leaves are firmly drawn with hard pastel; those below are still the original watercolor.*

5 *To make a color link between the background and the flowers, touches of muted green have been laid over the pinks and mauves, and are now lightly blended to soften the transitions of color and tone.*

▷ **Flowers by the Window**

Maureen Jordan • pastel and watercolor

Although you may want to emphasize one area of a picture, the subsidiary elements such as the background still play an important role and must be seen in the context of the overall composition and color scheme. Here, although the flowers are the focal point, there is interest everywhere, with the lovely soft haze of color in the background acting as the perfect foil for the yellows of the flowers and vase and rich red-brown of the tabletop.

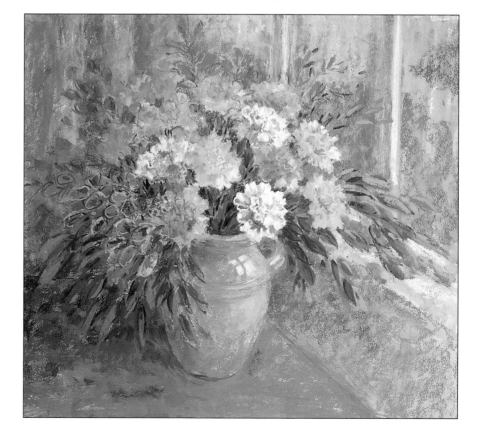

Dominant Shapes

SOME SHAPES NATURALLY DRAW THE EYE, FORMING AN OBVIOUS FOCAL POINT FOR YOUR PICTURE. TAKE CARE HOW YOU PLACE SUCH SHAPES, OR THEY MAY DETRACT FROM THE OVERALL COMPOSITIONS

CIRCLES AND REGULAR GEOMETRIC shapes seem to claim immediate attention, perhaps because they are more immediately recognizable than organic shapes, and the effect is even more striking when there is an element of contrast. In still life, circles, in the form of plates and round objects such as fruit, are often counterpointed by diagonals and square or rectangular shapes, with the freer shapes of fabric or flowers providing the contrast.

In landscape the eye will be drawn to any man-made feature, such as a house, a bridge or a tractor, even if it is quite far off, because it is different in kind from the gentler, less organized shapes of the landscape itself. But even natural objects can play this dominant role; the largest, tallest or most nearly symmetrical shape will stand out against smaller and less regular ones. One broad tree with a spreading canopy may dominate a summer landscape, as would a lofty tree in a flat setting – vertical shapes generally have a stronger presence than horizontals.

Placing the shape When your picture has an obvious focal point like this, take care how you place it. The golden rule in composition

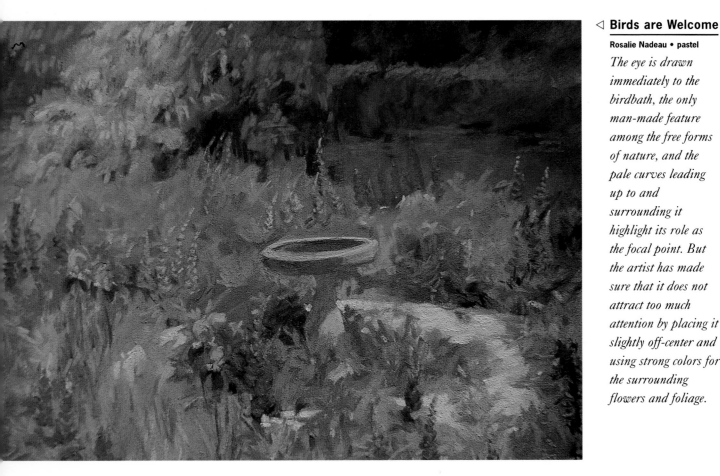

◁ **Birds are Welcome**

Rosalie Nadeau • pastel

The eye is drawn immediately to the birdbath, the only man-made feature among the free forms of nature, and the pale curves leading up to and surrounding it highlight its role as the focal point. But the artist has made sure that it does not attract too much attention by placing it slightly off-center and using strong colors for the surrounding flowers and foliage.

△ Distant Mosque, Istanbul

Peter Kelly • oil

Both the paintings shown on this page feature obviously dominant shapes, but the placing and treatment are very different. Here the dome and minarets, although distant, are the focal point of the painting, dark against the pale sky and middle toned hills. But the foreground water occupies the greater part of the picture space, so here the artist has introduced tones and colors which provide pictorial balance and bring the area forward in space.

◁ Punch and Judy

Nick Harris • acrylic

The precise placing and balancing of this foreground shape was vital, and the artist has planned the composition with care. The stall is placed off-center, with the strong shadow and dark blue rectangle of water providing a balance on the right and behind. The curly yellow-on-red patterns at the top of the stall find an echo in the carefully painted patterns of trodden sand.

△ **Walberswick Boat**

Alan Oliver • pastel

The inclusion of the stern of another boat on the right of the picture provides a balance and shape echo, preventing the main shape from becoming isolated, but it is treated sketchily so that it does not claim too much attention. The artist has also created links between foreground and background by letting the boat's mast go out of the picture at the top, and repeating shapes and colors from one area to another.

is to avoid symmetry as far as possible. You should encourage the eye to roam around the picture, seeing it as a whole rather than registering just one part of it, which is what will happen if the focal point is dead center. It can be dangerous also to place a dominant feature in the immediate foreground; this may act as a block, preventing the viewer from traveling any further into the picture space.

Echoing shapes Sometimes a shape may be too dominant wherever you place it, so you need to find ways of making it less intrusive. You can sometimes do this by reducing the tone and color contrasts between it and its surroundings, or by softening some edges, but you can also achieve it by a system of echoes. In a still life, you could make a bowl of fruit

◁ **Obsequent**

Jann T. Bass • watercolor

This painting is particularly interesting in that the dominant shape is a negative rather than a positive one – the bright triangle of water. The composition is based on the interplay of triangles; above the water, a clump of shrubs forms a dark shape, balanced by the mid-toned triangle of the fields and the lighter one of the far hills. Even the bank directly above the water is split into two distinct shapes by the pale line leading upward to the right. The sinuous pale shapes of the water bird and its reflection provide the perfect counterfoil for this geometric arrangement.

▷ **Summer Day** Martha Saudek • oil

The great billowing white clouds are the dominant shapes, emphasized with strong tonal contrasts. To form links between land and sky, the cloud shapes are echoed in the hills and trees below.

the focal point, but echo it with other smaller circles – more pieces of fruit, some flowers with roughly circular heads, or a cup and saucer. In landscape, you might echo a tall tree by giving extra emphasis to some foreground grasses, or use the shapes of cumulus clouds to echo those of foliage-clad trees, thus setting up a pattern of shapes throughout the picture.

People in landscape Like man-made shapes, people in paintings attract attention and become natural focal points, in this case because they are so familiar, and we identify with them in a way that we don't with trees or fields. So if your main interest is the landscape, it is safest to place figures in the middle distance, where they will draw the eye into the picture but not dominate it.

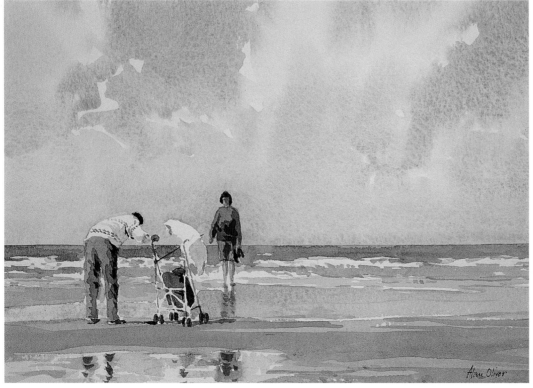

◁ **First View of the Sea**

Alan Oliver • watercolor

Here the figures are as important as the landscape because they "tell a story" as well as giving a sense of scale.

▷ **Salute at Sunrise**

Hazel Soan • oil

Like the painting of clouds above, this shows the use of echoes to integrate the dominant shape of the gondola.

Analysis

RHYTHM AND BALANCE

Two of these paintings use a dominant shape occupying much of the picture – the circular lake and the cone of table and cloth. In the third, the focal point is less obvious. Our eye is drawn to the figures, which provide a "story-telling" element in an otherwise severe composition, but passes over them to the red-on-yellow signs above.

What all the pictures share is a strong sense of rhythm. The three artists have set up systems of balance, whether of shapes, colors or tones, so that we are led around their pictures from one area to another. A further similarity is the use of relatively restricted palettes, which has helped to give unity to the compositions.

The spiky statues are an essential contrast, both of shape and of tone, for the large dark shapes.

The two strong shapes of the tree and its reflection prevent the eye from being taken out of the picture on the right and provide a balance for the curve of the lake.

△ **Versailles Reflections**

Joyce Zavorskas • monotype

The lake is placed off-center so that the curve leading from the left takes the eye in through the urn and bench toward the distant trees. The strong shapes of the trees balance the dominant circle, with their curving tops echoing the line of the lake's edge.

The shape of the reflection makes a natural link between lake and trees, but because it is painted green, there is also a color echo with the middleground hedges.

The yellows of the fruit and hat are the complementary of the dominant blue-mauves, but the artist muted them to ensure that they did not stand out too strongly.

The vase of flowers could have claimed too much attention, but was "toned down" effectively by the use of similar colors and tones for the background.

The steps play an important role in leading in to the tabletop, and also provide a tonal balance for the patches of sun and shade on the left.

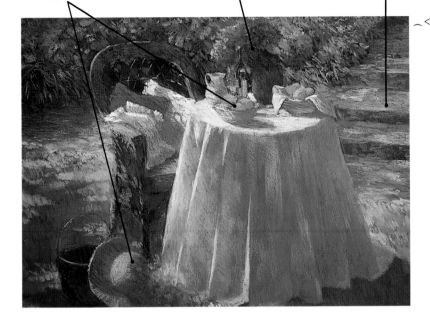

◁ **Summer Table**

Jackie Simmonds • pastel

This composition is based on a triangle, with the apex, the vase of blue flowers, almost at the top of the picture. Our eye naturally follows the diagonal folds of the cloth upward to the bowls of fruit and thence around the line of the chair and down to the hat and bucket, which echo the circles of the fruit.

The delicate linear pattern of the wire mesh links with the foreground railings and provides a lively background for the figures.

The shape of this shadow echoes those on the left and right of the figures. With the narrower band of shadow on the left, it also acts as a frame within a frame.

This is the brightest area of color in the picture, catching the eye and leading upward from the figures to the dark line of shadow.

▷ **Brighton Pier**

Sandra Walker • watercolor

The rhythm of this composition derives from the interplay of darks and lights, which form an intricate pattern over the entire surface. The figures are not over-dominant because the artist echoed their shapes, colors and tones elsewhere. The shape they make is similar to that of the shadow on their left; the ocher of the girl's dress is picked up again on the walls and columns; the blue-gray of the man's clothing reappears in all the shadow areas.

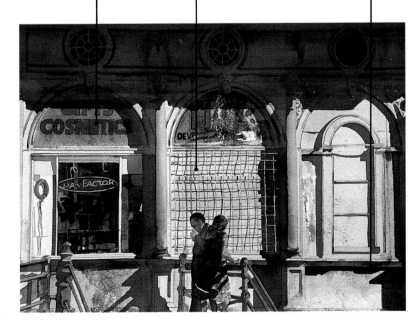

URBAN LANDSCAPE

THE ARTIST was struck by the way the arches and columns framed the sky, making these pale shapes the dominant ones, and she photographed the scene for later use. In the photograph, the arch was too centrally placed, so before starting the painting she made a charcoal sketch to work out a less symmetrical arrangement. The photograph also showed two figures, which she had not intended to include until she realized that they also made an interesting shape and provided a strong foreground. She thus made a second sketch. She is working in acrylic on Ingres pastel board, which she has prepared with a coat of acrylic gesso to provide additional texture, followed by an undercoat of light blue.

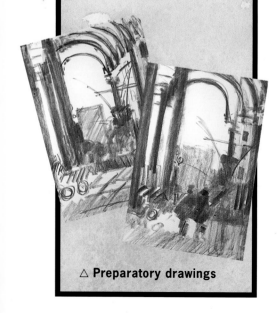

△ **Preparatory drawings**

1 *By providing a complementary contrast, the blue ground color makes it easier to judge the yellow now applied. A colored ground is very helpful when using opaque paints or pastels.*

2 *White paint, used very dry, is dragged over an earlier layer of yellow-brown and blue. You can see how the striated texture of the gesso ground breaks up the brushstrokes.*

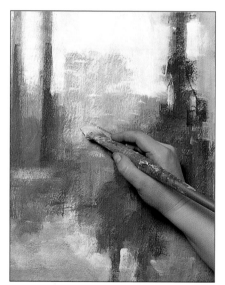

6 *The tall building was too obtrusive, breaking up the large shape of the sky, so it is modified with light scumbles of very pale pink and gray.*

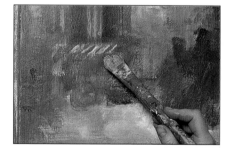

7 *The awning and rails required further definition and an intensification of color to balance the tonal contrast and touches of detail on the right of the picture (see Step 5).*

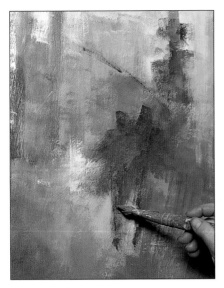

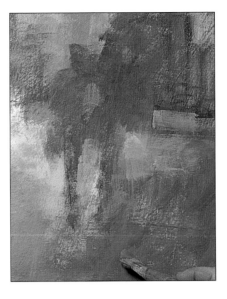

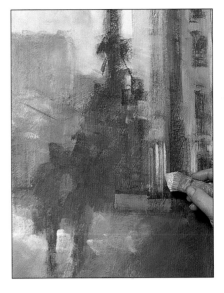

3 *The artist dislikes areas of flat paint and here again exploits the broken-color effect of dry paint scumbled over texture. The figures are simplified, treated as a single dark shape.*

4 *A more intense version of the blue used earlier (see Step 2) is introduced into the foreground to continue the blue-yellow theme of the painting.*

5 *A point of interest was needed in this area of the painting to lead the eye from the figures to the light shape of sky. Delicate lines of yellow are made with the tip of a worn brush.*

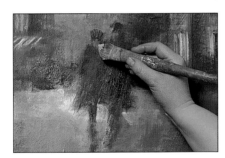

8 *Finally, the figures are given credibility and a suggestion of form with touches of yellow and brown. Fine detail, which could make them over-dominant, is avoided.*

▷ **Hay's Galleria** **Debra Manifold • acrylic**
The figures have been handled very cleverly so that they do not dominate the picture but are integrated into it, allowing us to read the composition as an interplay of shapes. This is partly due to the deliberate suppression of detail, but the limited color scheme, with blues and yellows repeated from one area to another, plays a part.

Camouflaged Shapes

Small shadows can disguise shapes by breaking up the outlines, and reflections sometimes confuse forms. The effects of light are an exciting challenge to the artist

IF YOU HAVE EVER tried to paint woods in summer, with the sun shining through leaves to create an intricate pattern of light and shade, you will appreciate some of the problems involved. What your eye registers first is not the big forms, such as tree trunks or ground contours, but myriad tiny shapes – those of leaves highlighted by the sun, in shadow, or casting their own shadows on adjacent trees.

These appealing effects are obviously the main impression you want to capture in your painting, so the pattern of the "camouflage" is more important than the shapes it hides. But unless you also suggest the larger shapes, there is a danger that your painting may become disjointed. Usually, even if patches of shadow partially obscure a tree trunk or branch, you can see areas where an edge is well defined against a darker or lighter background, and you only need to "find" one or two or these edges between areas of foliage.

Thoughtful brushwork In Part Two of the book you saw how small shapes can be defined with one or two brush- or pastel marks, and this kind of subject is well suited to building up through individual strokes rather than flat color. But don't put down a series of random splotches; look carefully at the small shapes of leaves, patches of shadow and tree trunks and see if you can describe them by varying the brushwork. For example, you might use an upward sweep of the brush for a tree trunk, long horizontal strokes for shadows on flat ground, and little tapering marks sloping in different directions for leaves. Avoid too much detail, picking out the shape of a leaf or branch here and there.

Reflections in water Reflections also play tricks which can lead to confusion. The reflections in still water show you a virtual

△ **El Jardin Andalue** Pip Carpenter • watercolor

By freely translating the effect of sunlight on foliage, the artist has produced an almost embroidered effect which is both lively and highly evocative. The man-made features – the round table at bottom left, with the steps and side of a building above – give a touch of stability to a composition in which everything appears to be in dancing movement.

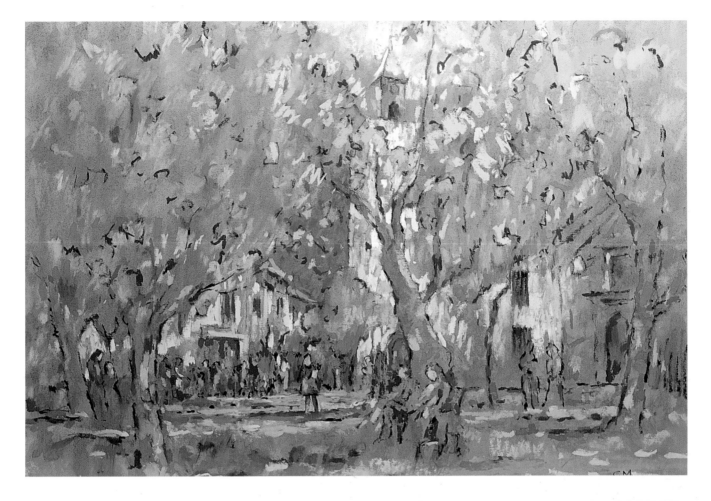

△ **Machico Church and Square, Madeira**

Geoff Marsters • pastel

*The effect of bright, shimmering light has been
achieved in part through the use of complementary
colors – yellow and violet. Touches of dark pastel
define the shapes of the trees, figures and
buildings, but the handling of edges and outlines
is very light and delicate.*

▷ **July 12th**

Kitty Wallis • pastel

*The reflections have been treated with the same
lively and energetic pastel marks as the trees
above, which integrates the composition. The
horizontal plane of the water is made explicit by
the clumps of floating weed, but it appears also to
exist as a vertical plane, creating a complex and
fascinating effect.*

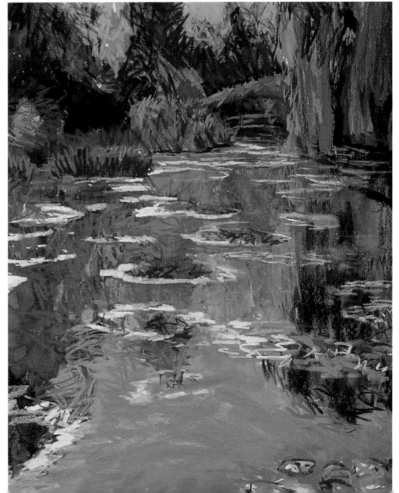

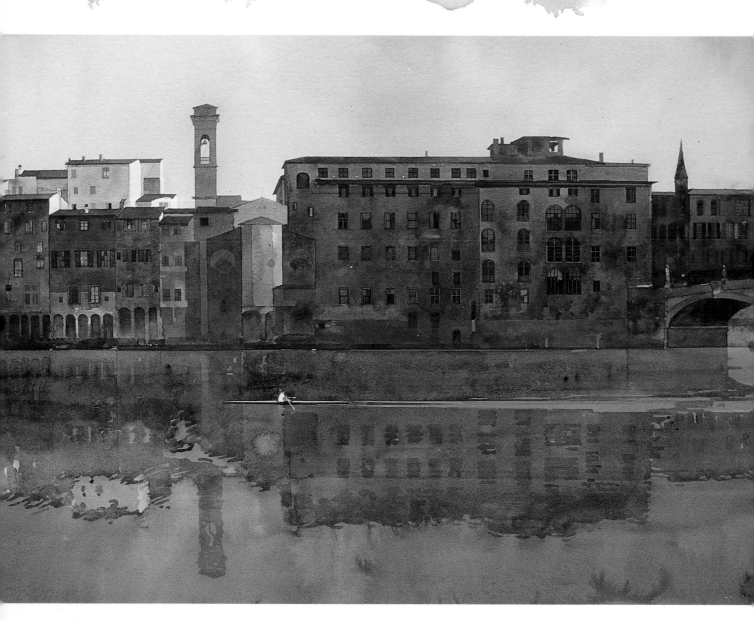

△ **Rowing in the Arno**

Peter Kelly • watercolor

There is lovely contrast between the solid, unmoving shapes of the buildings and their impermanent watery reflections. They could shift or disappear at any moment, and this feeling of transience is stressed by the boat streaking across the water, leaving a long and dramatic wake.

mirror image of the objects reflected, fooling you into seeing a vertical plane instead of a horizontal one, so you will need to suggest the water surface in some way.

There is usually something that helps you to do this – one or two ripples, or perhaps some floating leaves. But you can also make the distinction between objects and their reflections by softening the edges slightly; however still the water, reflections are never quite as hard-edged as the objects, and the transitions of color and tone are less marked.

In still water, reflections are the same height and width as the objects, but disturbed water breaks up the shapes and scatters them sideways or downward. These effects can be complex, calling for careful observation and usually some degree of simplification.

Reflective and transparent forms Reflections on polished surfaces, such as metal, can have the effect of disguising the form, especially if the object is reflecting some entirely different shape next to it. An example might be the reflection of a book on the surface of a silver pitcher. The reflection would not be totally straight-sided because the curve of the pitcher would distort it, but it would still tend to contradict the form. In such cases consider using only the helpful reflections – those that explain the form – and omitting others, or playing them down.

Glass objects can be tricky because you are seeing through one curved surface to another. But because glass reflects light, you will usually find highlights that help you describe the shape. The rim at the top of a

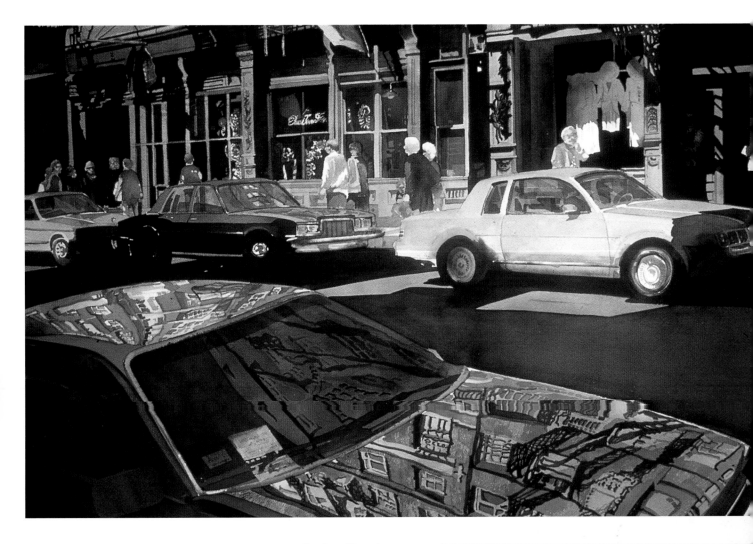

Spring Street

Sandra Walker • watercolor

The reflections have been treated in detail, but the outlines of body and windscreen make the shape of the car perfectly understandable.

glass jar, for example, often catches the light. Also, the glass is often thicker at the base for practical reasons; this reduces the transparency so that you see a dark curve at the bottom marking the ellipse.

Another difficulty with glass objects is that they distort shapes behind them. As light travels through a curved transparent surface, it bends, causing displacements and magnifications. This distortion is most obvious at the edges, where the object curves most sharply away from you; in the center there may be very little. With keen attention to these effects, you can create the impression of a glass object very economically. Begin with the background, then look for visual clues, such as highlights that reinforce the shape.

▷ **Roses in a Glass Jar**

Maureen Jordan • pastel

In this delicate painting, the form and shape of the jar is defined by precise placing of the highlights and the bottom ellipse.

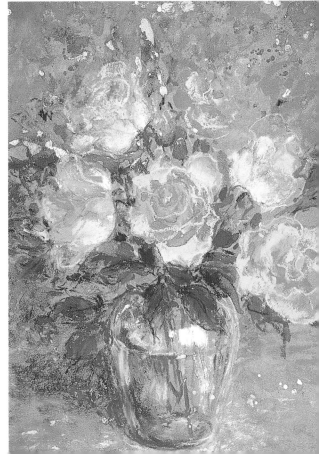

LIGHT AND SHADOW

WATERCOLOR, portable and quick to apply, is an ideal medium for recording fleeting effects of light. But beware of overworking or you will quickly lose the very effects you are seeking to convey. Remember that watercolor becomes much lighter when it dries, so test your colors on a piece of spare paper so that you don't have to darken them with overlaid washes. Here, there are almost no overlaid colors; each brushmark and area of color has been laid down and left alone except where minor amendments were needed. The composition was planned in advance with a pencil sketch (below), and a soft-pencil drawing made on the working surface as a guide for the first washes.

▽ **Preliminary sketch**

❶ *A light drawing was made with a soft pencil, and the painting is begun wet-into-wet. The paper is dampened all over except in the central area where the light comes through.*

❷ *The paint has been stopped by the dry paper, forming a crisp-edged white shape in the center. Elsewhere, the colors have been applied separately so that they have mixed only to a limited extent.*

❻ *Rather than building up the darker tones and colors in a series of overlaid washes, he lays down brushmarks of full-strength color and leaves them alone as far as possible.*

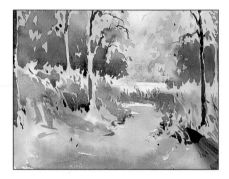

❼ *Now that the background and middleground colors are in place, he can judge the strength of tone and color needed for the foreground. Notice the varied and highly descriptive brushwork in this area.*

❽ *The patch of light in the center is the focal point of the composition, and to emphasize it, darker color is laid on the foliage. The tone of the right-hand tree has also been strengthened.*

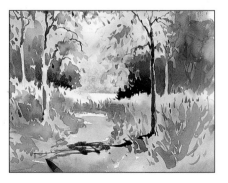

❾ *The shadow is left until last so that its tone and color can be assessed next to the foliage and grasses. Compare this with the finished picture to see how much darker watercolor looks when wet.*

3 *The paper can be covered quickly by working wet-into-wet, and the artist now has an underpainting on which he can build up with individual brushstrokes applied wet-on-dry.*

4 *Having drawn in the trunk and branches of the tree with the point of the brush, he takes dark paint carefully around the sunlit side, leaving a fine line of white highlight.*

5 *Moving across the painting, he now works on the left-hand tree, again using the point of the brush to "draw" fine lines and drop in tiny blobs of paint.*

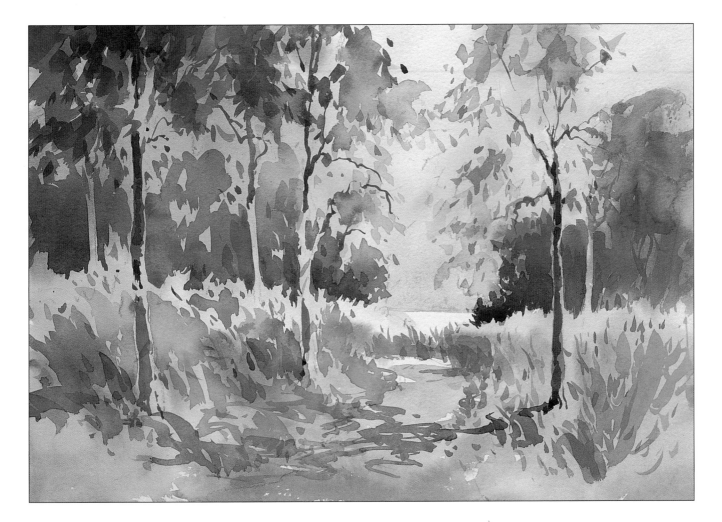

The Spinney Alan Oliver • watercolor

The untouched areas of white or near-white paper give the painting a fresh, airy quality, and the calligraphic brushwork imparts a lively energy which could not be achieved with flat washes. The brush has been used almost as a drawing implement, with deft one-touch strokes describing each separate shape. The artist sees drawing as the basis of good painting, and in all his work the markmaking forms an integral part of the image.

Pictorial Values

SOME SHAPES ARE RESTFUL AND DO NOT CLAIM IMMEDIATE ATTENTION, WHILE OTHERS HAVE AN INTRINSIC EXCITEMENT. YOU CAN USE SHAPE AND EDGE QUALITIES TO GIVE EXPRESSION TO YOUR WORK

NO ONE QUITE KNOWS why, but colors have emotional associations. Red, for example, is seen as commanding or even aggressive, which is why it is used for warning signs, while blue and green are peaceful. It is the same with shapes – some convey tranquility and others have inbuilt dynamism.

People react differently to both colors and shapes, so their emotional qualities can't be precisely defined, but in general, verticals

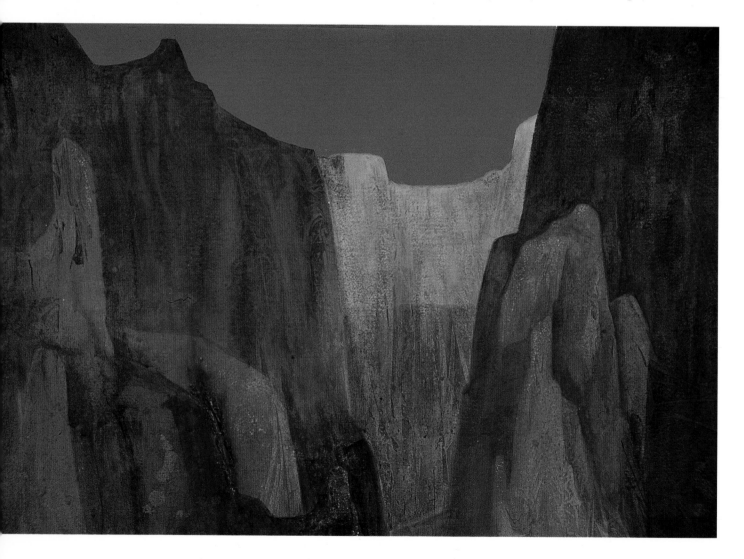

△ **Canyon Walls** Shirley McKay • acrylic
These tall, angular shapes have an inbuilt element of drama. The artist has gone for the large shapes, simplifying where necessary, and avoiding hard internal edges that might weaken the impact; these edges, in comparison with those where the rocks meet the sky, are quite soft.

are more exciting than horizontals, and sharp curves than flowing ones. As we have seen, circles and geometric shapes catch the eye, but they don't arouse emotion. Jagged, upright shapes do; in fact, they can be disturbing, especially when combined with sharp edges and contrasts of tone.

Creating atmosphere Using shapes and edges as a means of expressing or arousing emotion obviously involves consideration of tones and colors also – the shapes alone won't do the job. The most restful effects are created by avoiding hard edges and strong contrasts of tone, and choosing harmonious, or related, colors. These are the ones that appear next to one another on a color wheel: blue, mauve and purple/blue; red, orange and yellow. The colors in the second group are warmer than the first, so you need to tone them down, as you would when painting a landscape at sunset.

△ **Meadow**

Lois Gold • pastel

In contrast to the painting opposite, the shapes and colors here create a quiet, restful feeling in keeping with the subject.

◁ **Swimming Pool, Sauces Nord**

David Cuthbert • acrylic

A deliberate distortion of perspective, with the swimming pool tilted slightly upward, has created an intriguing interplay of shapes.

◁ **Roses and Ribbons**

Urania Christy Tarbet
• pastel

The pinks, blues and violets that predominate in this lovely painting are all close to one another on the color wheel, and thus form a natural harmony. To prevent the color scheme from becoming monotonous, the artist has also introduced yellow, the complementary of violet.

For a lively atmosphere, accentuate edges and bring in contrasts, both of color and tone. If you want high drama, or an unsettling feeling, the more contrast the better, and you can introduce the special contrast between complementary colors. These are the colors opposite one another on a wheel – red and green, yellow and mauve, orange and blue. They need to be treated with care, since they create very vibrant effects. A small touch of red in a summer landscape will simply enliven the greens, but if you use complementaries in equal or near-equal quantities, they can be distinctly disturbing.

The picture surface When you begin to paint, your main concern will naturally be to find ways of describing what you see, but a painting has its own existence, related to but independent of what it depicts. The way you use your brushes or pastel sticks will cause them to create their own shapes and edges on the picture surface.

For Monet, who built up his paintings in variously sized brushmarks of opaque paint, giving an almost patchwork effect, the picture surface was inseparable from the subject – in

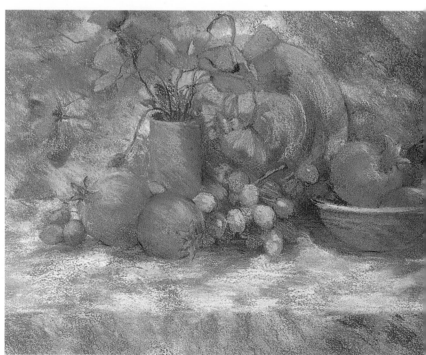

△ **Poppies, Grapes and Pomegranates** Jackie Simmonds • pastel

Like the other pastel painting above, this one makes use of complementary colors. Here the main complementary pair is red and green, but there are also touches of yellow and violet. Used at full strength, these "opposite" colors can be over-bright, but in both paintings they have been deliberately muted to create delicate effects.

▷ **Farewell Stelae**

Susan Wilson • oil

Strong contrasts of tone create dramatic effects, but overall use of dark and middle tones and dulled colors give a somber, even sad feeling, as in this moving painting. The expressiveness of the picture derives partly from the precise and skillful control of color and tone, but equally from the paint handling.

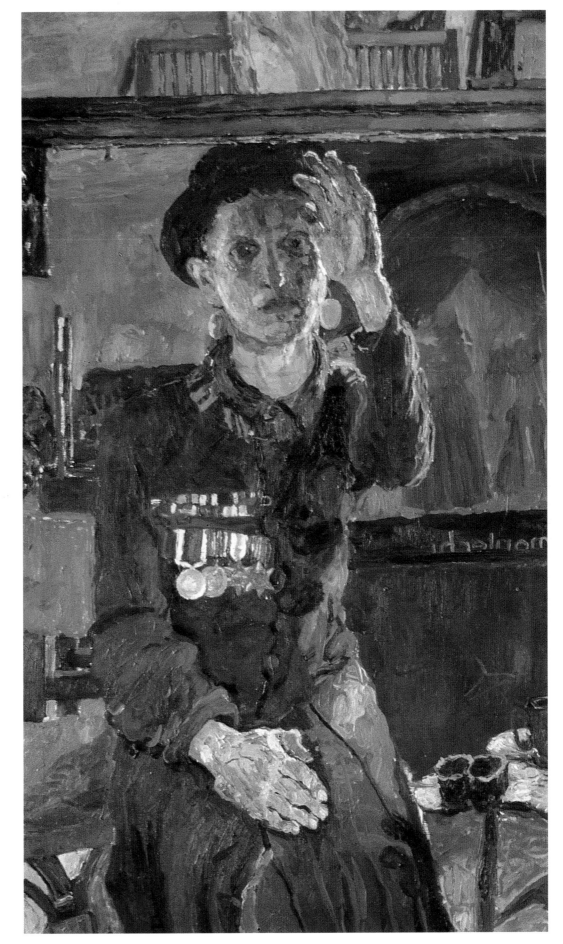

▷ **Barges at Ipswich**

Geoff Marsters • pastel

Pastel is a medium well suited to optical mixing methods, and the artist has given a lovely shimmering quality to the sky, water and background trees by placing small strokes of different colors side by side.

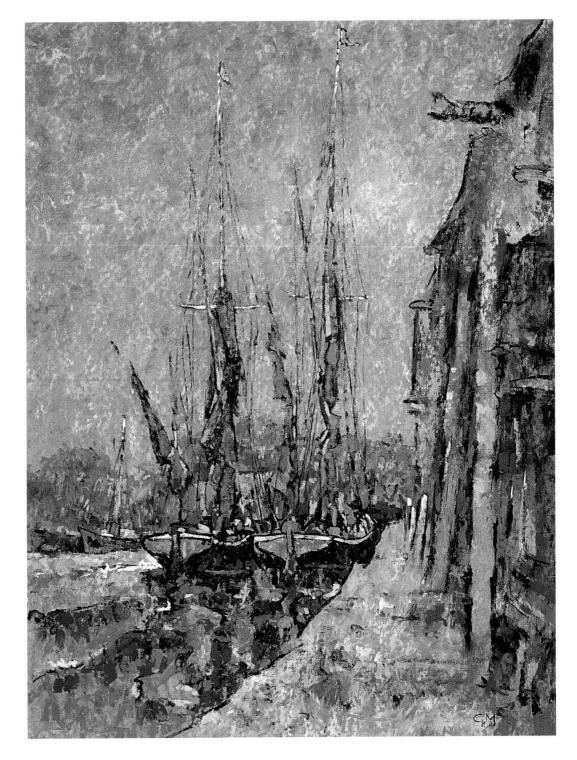

◁ **Miranda**

Arthur Maderson • oil

This artist is known as a "modern Impressionist," and his technique reflects Monet's fascination with the picture surface and Seurat's experiments in the optical mixing of color. Brushstrokes of rather dry color are laid over and next to one another so that they merge in the eye when viewed from a distance. The effect here is quite breathtaking, with the shapes gradually emerging through the intricate web of small brushmarks.

fact, it virtually became the subject. Cézanne's square, brick-like brushmarks play more than a merely descriptive role; they reinforce the structure of his compositions. Van Gogh expressed his feelings about himself and his subjects through some of the most exciting brushwork ever seen, using paint in swirling strokes, slashes or jabs.

These artists were oil painters, but all the painting media allow expressive mark-making. In watercolor you can exploit the hard edges formed as washes dry; in pastel you can vary the size and direction of the strokes, contrasting crisp linear marks with soft side strokes; and in acrylic you can do almost anything you choose, applying the paint with a knife to create a series of light-catching edges, or even mixing it with sand to provide a heavy surface texture.

PATTERN AND SURFACE

THERE are different kinds of pattern in painting. An artist may exploit existing patterns within a subject, such as printed fabrics and decorated ceramics in a still life. Or objects may themselves create a pattern, as in *Koi Fish*.

A more subtle form of pattern relates to the picture surface, and is produced by the brushmarks or pastel strokes. In the other two paintings the brushmarks create shapes that, although related to the subject, have an almost independent existence. Good paintings have a life of their own, and all of these show the artists' equal concern for pictorial values and a truthful depiction of their subject matter.

The waterlilies provide a contrast of shape and color, and also acts as a stabilizer, anchoring the fishes within the picture's boundaries.

The disturbed surface of the water creates a rippling pattern on the body of the fish beneath.

△ **Koi Fish**

Joan I. Roche • watercolor

There is a strong element of both pattern and movement in this delightful painting, with the elegant shapes of the fishes, pale against the dark water, crisscrossing in perpetual restless motion. Within this main framework, there is a wealth of subsidiary pattern, on the fishes' bodies and in the water.

The sense of movement is enhanced by the fish darting out of the picture while another swims in at the top, giving the impression that they have been "caught" for no more than a second or two.

▷ **Shepherd's Crag, Borrowdale**

Bill Taylor • watercolor

The impression of freedom and spontaneity was in fact achieved by careful advance planning. The artist likes to use full-strength colors from the beginning rather than building them up in layers. Mainly flat brushes were used, producing large, angular shapes that express the rocky landscape more eloquently than a highly detailed treatment would.

Brushstrokes of liquid friskit (masking fluid) were applied with a broad brush and removed after the blue was put on, producing crisp-edged white strokes.

Although these brushmarks are ambiguous in descriptive terms, they have an important place in the overall pattern of brushmark shapes.

Rough paper was used, giving an extra dimension of surface interest.

In order to unify the painting, the yellow of the tree is repeated on the rocks, reflections and canoe.

The acrylic was used thickly and mixed with retarding medium, enabling brushstrokes to be blended wet-into-wet.

◁ **Pont d'Arc, Ardèche**

Ted Gould • acrylic

The texture of the paint and the pattern of brushmarks are integral to the composition, just as they are in a painting by Cézanne or Monet. In spite of these dominant surface qualities and the lack of detail, we have no difficulty in reading the painting as a depiction of three-dimensional space.

The brushstrokes follow the directions of the forms, with broad horizontal marks for the flat plane of the water.

Demonstration

RIVER SCENE

IF you ask artists why they use a particular brushstroke they will probably say it is instinctive. This is not helpful for the newcomer to painting, but unfortunately it is true, and as you become more practiced you will find that you unconsciously evolve your own approach to the painting process. The first step is to learn to think in terms of the picture itself. So instead of worrying about whether the shapes are exactly true to life, consider whether they work in pictorial terms and whether the marks you make to describe them add to the overall effect. This demonstration, in oil paint on canvas, may give you some ideas: the painting is more than a simple depiction of boats on a river.

1 *Many oil paintings begin with an underdrawing, but this artist dislikes the idea of "filling in" a drawing, and works in color from the outset.*

2 *The paint is first used very thinly, diluted with turpentine. But it still holds the marks of the brush, which is here pushed onto the surface.*

6 *A small patch of broken texture is made by splaying out the brush hairs slightly and gently dabbing on thin paint.*

7 *The artist lets the brush do the work of describing the shapes of the boats, carrying first light and then darker paint around the outer and inner edges.*

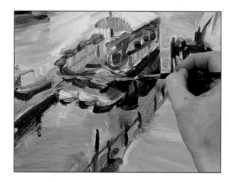

11 *The mooring rope is important, because it makes a visual link between river and land. It is painted with separate brushstrokes of thick paint.*

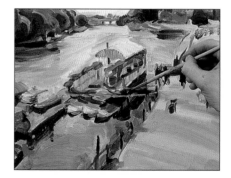

12 *Another rope was added behind the first, and the edges are neatened by cutting in around them with dark paint.*

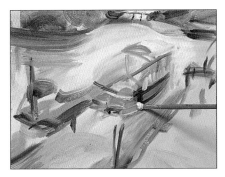

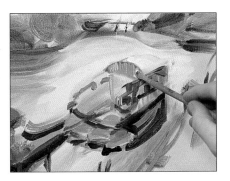

3 *Paint thinned with turpentine dries rapidly, so thicker paint can now be added without mixing into the underlayer.*

4 *Vertical strokes of thicker paint are used for the side of the boathouse. The strokes on the roof and sides curve around the shapes.*

5 *The forms of the trees were blocked in with multi-directional strokes, and sweeping curves are now painted beneath to suggest moving water.*

8 *The people on the bank contribute to the painting's atmosphere, but do not need detailed treatment. One or two flicks of the brush are used for each.*

9 *Moving once again to the back of the picture, the trees are given further shape and tonal contrast with broad, bold brushstrokes.*

10 *The trees and river are now satisfactory, but the boats and boathouse need further definition.*

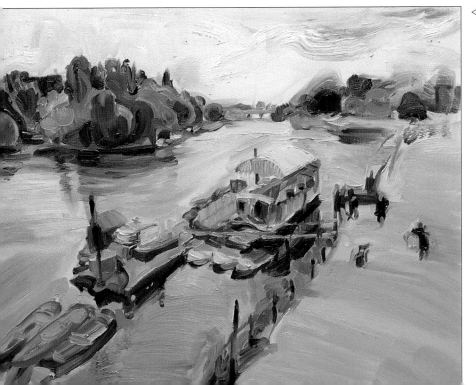

◁ **Off Richmond Bridge**

Karen Raney • oil on canvas

A photograph of this scene might look dull, but the painting is full of life and excitement. Some of the details are ambiguous, for example the mooring ropes might equally well be the rails of a jetty, but it does not matter; Karen Raney has extracted what is important in pictorial terms. The painting has a powerful sense of rhythm which derives from the repeated use of curves. In particular, the brushstrokes used for the river echo the curve made by the line of boats, so that we are swept into the composition.

INDEX

Page numbers in *italics* refer to illustrations.

CREDITS

Quarto Publishing would like to thank all the artists who have kindly allowed us to reproduce their work in this book.

We would also like to acknowledge and thank the following artists for their help in the demonstration of techniques: Rima Bray, Jean Canter, Pip Carpenter, David Carr, David Cuthbert, Ros Cuthbert, Hazel Harrison, Jane Hughes, Maureen Jordan, Debra Manifold, Alan Oliver, Karen Raney, Annie Wood.